RYEDALE

From Old Photographs

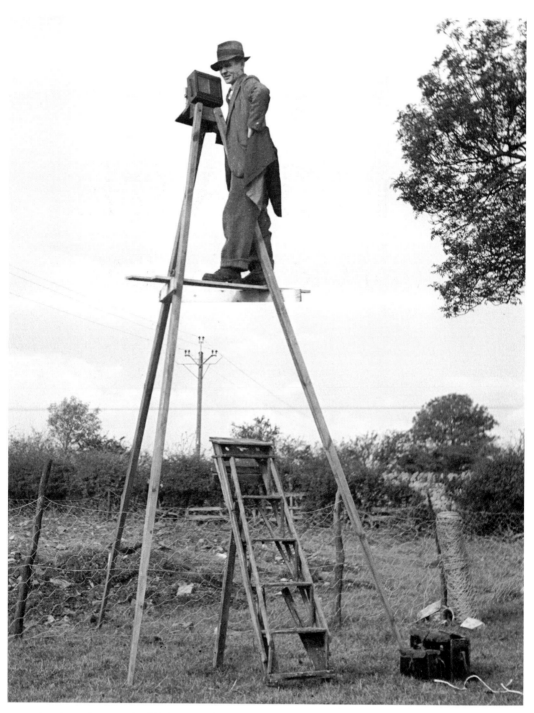

A unique photograph of Sydney Smith on top of a home-made tripod which he used to take photographs for Dr J. L. Kirk of the Roman villa at Rudston. Dr Kirk excavated the site and Sydney Smith produced a set of over fifty postcards, including the complete mosaic floor. This picture will have been taken by his wife, Maud.

RYEDALE

From Old Photographs

GORDON CLITHEROE

[signature] G. Clitheroe 13-12-2013.

AMBERLEY

I dedicate this book to all my friends in Ryedale who have opened my eyes to the beauty and richness all around us, and some who have shared my company and walked in my footsteps over its rolling hills and dales; also to John Rushton for my involvement with Beck Isle Museum, and to all the people I have been privileged to meet and learn from – they have all made their mark on me; and finally to my patient family who try to understand my love of old photographs, the Ryedale area and its wonderful inhabitants.

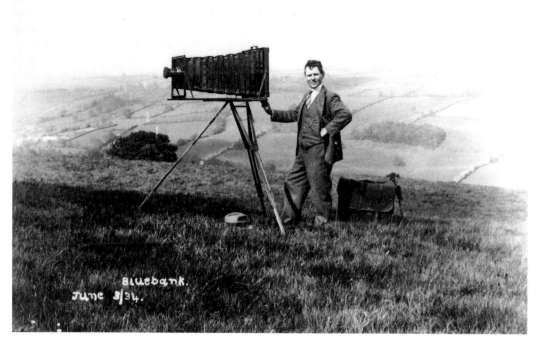

A classic photograph of Sydney Smith at work with his camera and tripod, on the moors near Bluebank, Sleights, 3 June 1934. It was used by Smith as a postcard and was taken by his young daughter, Barbara.

First published 2000, reprinted 2002
This new edition published 2010

Amberley Publishing Plc
Cirencester Road, Chalford,
Stroud, Gloucestershire, GL6 8PE

www.amberley-books.com

Copyright © Gordon Clitheroe 2010

The right of Gordon Clitheroe to be identified as the Author of this work has been asserted in accordance with the Copyrights, Designs and Patents Act 1988.

ISBN 978 1 4456 0114 4

British Library Cataloguing in Publication Data.
A catalogue record for this book is available from the British Library.

Typeset in 8.5pt on 12pt Sabon.
Typesetting and Origination by Fonthill.
Printed in the UK.

Contents

Acknowledgements

I would very much like to thank the following people for their help, advice and encouragement, and once again for their patience and good humour when I arrive on their doorstep: for supplying me with information, identifying people and places on the photographs, and lending me their photographs and postcards. I am also grateful to all the people who have lived and worked in Ryedale, who have enthralled me with fascinating tales of 'times gone by'. It has been my privilege to share some of the area's unique past with you all. My apologies to anyone whose name I may have inadvertently missed.

Ron Scales, Denys Hey, Mrs M. Maw, Geoffrey Smith, Miss B. Aconley, Mrs A. Dale, Mr R. Boyes, Mrs M. Croot, Eric Bowes, John Robinson, Albert Stead, Ron Holiday, Mrs D. Hill, Ron Warriner, Mrs J. Taylor, Frank Carrington, Eric Welburn, Alan Raw, Miss E. Simpson, Mrs P. Frank, Mrs M. Harland, Mrs T. Hornby, Miss O. Arundale, Mrs R. Buttery, George Stephenson, Tom Hebden, Mrs M. Finney, Ian Hodgson, Norman Duck, Mrs B. Fletcher, Mrs A. Hoggard, Stephen Welford, Thomas and George Smith, George Magson, Mike Burton, Mrs E. Briggs, Harry Dresser, Lewis Sommerfield, Paul Haywood, Frank Skaife, Barbara Sokol and her family; also the Trustees and Management Committee of Beck Isle Museum in Pickering for their continued support.

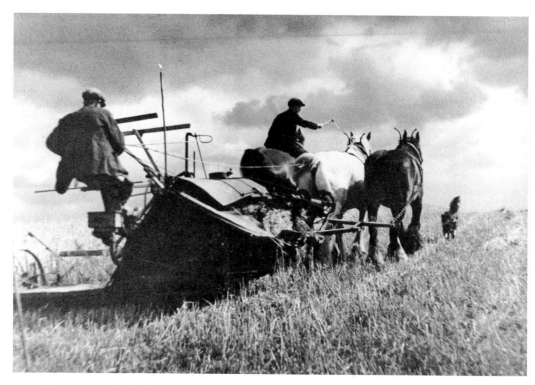

Harvesting with a binder at Lockton in 1935.

Introduction

Following the success of my first book in this series, called *Pickering*, I have been asked by many people to compile a second. This has been made possible largely by the sheer volume of photographs taken by Sydney Smith of Pickering, which form the greater part of the Beck Isle photographic collection in Pickering. Sydney Smith and his wife Maud, of Pickering, travelled to most of the villages in Ryedale, capturing its beauty and its hard-working people, and also events like floods, snowstorms and accidents, as well as portraits of people and animals. He supplemented his studio work and stunning landscapes by producing sets of postcards for sale, which are a remarkable record of the area, spanning over fifty years. The sets contain as few as four cards, but often up to thirty-six. He carried on working until his retirement in 1956, at the age of seventy-two. Sydney and his devoted wife, Maud, recorded some of the best of Ryedale's beautiful images and he was one of the finest photographers that this country has produced; it is only now that his work is getting the worldwide recognition it rightly deserves. This is partly due to the changing photographic exhibitions on display at Beck Isle Museum. I have also used photographs taken by other photographers in order to make the book as interesting as possible; where known, the name of the photographer is indicated at the end of the accompanying caption.

THE ORIGINS OF THE MUSEUM COLLECTION

At the age of twelve I spent all my pocket money on my first camera, while on holiday in Bridlington. On returning home, I was sent by my mother to Mr Smith's shop to be shown its loading and operation. Sydney loaded the camera without saying a word and then passed it to Maud who explained everything I needed to know. This was my first meeting with Sydney and Maud Smith. In 1967 I helped John Rushton and others to found Beck Isle Museum and Arts Centre in Pickering. Three years later John received a telephone call from Maud Smith saying that she was having to clear out her late husband's workshop in Park Street, and she offered to donate one of Sydney's large cameras. We had to collect it the following Sunday morning as a lorry had been ordered from the local council to remove everything the following Wednesday and take it to the local tip. When Maud unlocked the door into the dark, damp and dirt-covered room, we were amazed at the contents, which included cameras, glass negative plates and prints in plywood boxes that had been penetrated by woodworm which had bored through both plywood and prints. We were saddened that this room full of history was destined to be destroyed for ever, but we were also overwhelmed by the daunting task of what to do in order to save it. Maud Smith agreed to donate everything to the museum if we could remove it the same day. We worked all that Sunday afternoon and removed everything. The whole collection was covered in dirt and it was stored inside one of the museum outbuildings, to be cleaned and treated for woodworm at a later date. Little did we know then that we had saved a major photographic collection from oblivion, and that we had rescued nearly 2,000 of Sydney Smith's photographs. Some time later the work of Sydney Smith was put on display inside the museum. When visiting the museum, Maud was obviously proud of her husband's work, but also a little sad, as the photographs brought a lifetime's memories flooding back to her. She was, however, delighted to see that at last Sydney's work was on display for everyone to see. Maud herself was also an accomplished photographer, but she always played down the part she took in recording these works of art, and was adamant that she had nothing to do with his work, at least not 'His Pictures'. These were his

own work entirely, she declared. She had 'only' helped with his studio work – run the shop, gone out to take weddings and other celebrations, helped to carry half a dozen heavy glass negative plates, tripod and camera, worked in the darkroom on negatives and printing, loaded his camera while he spent hours capturing a romantic landscape. After Maud's death in 1994, I realised how few of Smith's postcards we held in the museum collection and their wealth of historical content. We have therefore started actively to collect more of these postcards, or borrowed them from private collections, to make up this deficiency, and the progress we have made enables me to share some of their amazing work with you. Not only was all this history recorded for our knowledge and enjoyment, but it was done with such superb quality that it has survived the test of time and ensured that Sydney and Maud Smith will be remembered for ever.

SYDNEY SMITH

Sydney Smith was born on 5 April 1884. Some of his early work has his name Sydney printed on the back, yet all his postcards spanning fifty years' work are embossed 'Sidney', as is his gravestone. To the inhabitants of Pickering, he was simply their own Sid Smith. Born into a family of Pickering builders, he lived at 1 Franchise Terrace, Pickering, the whole terrace having been built by his father. He was the youngest of twelve children, and was to spend all of his life in the town. He started work at fourteen as a delivery boy with the Co-operative Stores, where the manager showed him how to make a pinhole camera. He then served four years' apprenticeship with a joiner in Middleton, which was to serve him well in future years. Soon afterwards, he opened up a photographic business in a lock-up shop in Park Street. In February 1912 he bought a coffee house at 13 Market Place in Pickering, and later moved in with his new wife, Maud, having converted it into a shop and studio. They lived above the shop for forty years. Sydney fought in the First World War, during which time the photographic business was run by Maud, but on his return he gave up his photography in order to run a garage in Park Street, later to be run by his son, Edmund. However, he never gave up his first love of photography, and would spend all his spare time taking photographs. It is astonishing that he ever took up photography at all, as he suffered from defective vision, the result of contracting measles as a boy; in order to focus his camera he needed to use a magnifying glass. Though a friendly man, he was shy and essentially a loner, but despite his poor eyesight he was one of the first three men in the town to ride a motorbike and one of the first to own a motor car. In later years he would ride a push bike with one of his Yorkshire terriers riding in a box on the front. As his eyesight deteriorated, Maud would drive the car, constantly halted by the cry of 'Stop!' as Sydney's attention was caught by some fleeting effect of light. His interest in vehicles led him to own motorcycles and various three- and four-wheeled cars, including a Morgan that he converted into a three-wheeled van. In addition to being an expert photographer, Sydney was also an accomplished 'do-it-yourselfer'. He installed an engine in the studio for moving the back scenery and running a generator. He also at one time installed a searchlight, which would light up the sky from the roof of his workshop. Sydney was also an accomplished musician and was able to play a number of instruments well. The family enjoyed the countryside so much that most weekends would find them camping on the edge of the moors and the children would appear in many of the moorland scenes. The Smiths had two children: Edmund and Barbara. Edmund was to work in the family garage on Park Street and later took over the running of it. Barbara helped her father and took two memorable studies of him on the moors, with his large plate camera and tripod. Later she married and went to live in Canada. Sadly, Edmund was killed in an explosion at a north-eastern factory on 2 May 1945. He was only twenty-nine years old. In 1956, when Sydney was seventy-two, the Smiths sold their shop in the Market Place and retired to Beacon Park. By this time Sydney's eyesight was getting worse and an eye operation failed to improve things. A year later he opened a hospital window, which he mistakenly thought was on the ground floor, and fell out. The fall resulted in a broken hip, pneumonia set in and he died on 3 October 1958, aged seventy-four. Maud lived on until 3 February 1994, aged ninety-four.

The legacy that the Smiths have given us is a beautiful and accurate record of our market town and the countryside around it.

One

Landscapes

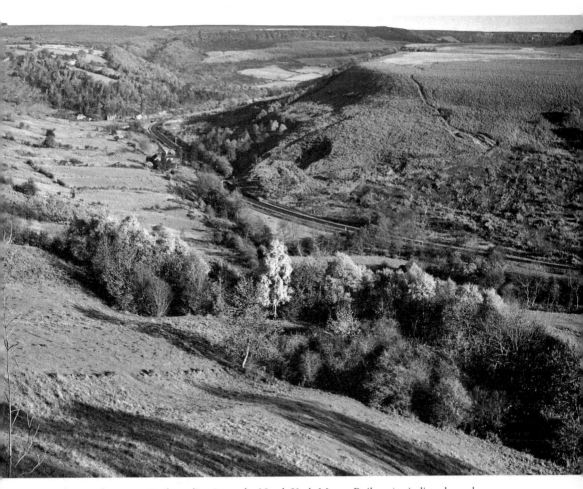

The North Eastern Railway line (now the North York Moors Railway) winding through Newton Dale in the direction of Whitby. On the left is Raindale Mill, which has since been dismantled and rebuilt near the Castle Museum in York. (Sydney Smith)

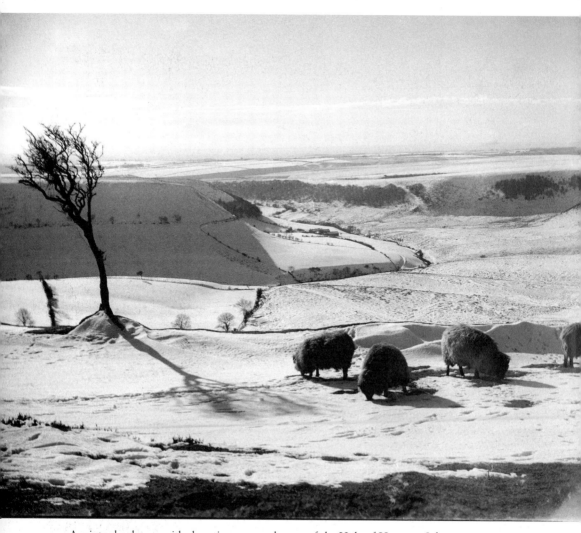

A winter landscape with sheep in snow at the top of the Hole of Horcum, Saltersgate. (Sydney Smith)

Below opposite: Lodge Farm, Stape. This farm was owned by Herbert (Dobby) Eddon at the time of this picture. (Sydney Smith)

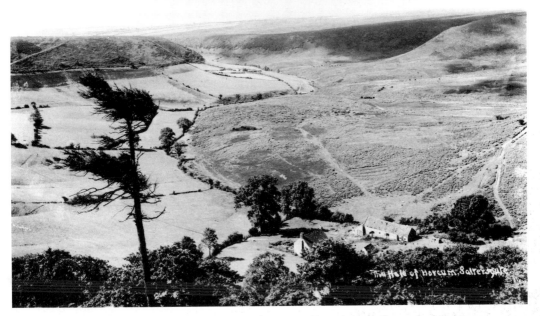

Above: The Hole of Horcum, Saltersgate. High Horcum Farm is in the foreground and Low Horcum is in the distance. Jack and Florrie Mackley were the last occupants of High Horcum. In 1963, soon after they moved out, the roof was damaged by an avalanche of snow and the farm has since been demolished. (Sydney Smith)

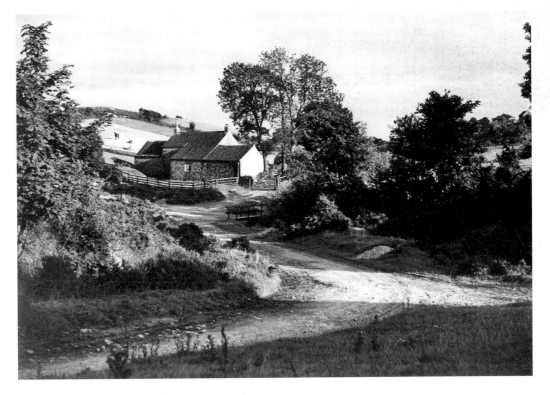

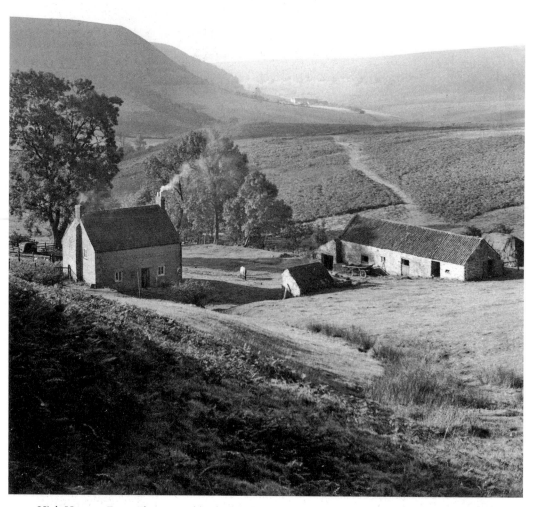

High Horcum Farm. Florrie Mackley had to light two fires so that smoke could be seen coming from the chimneys, and she was then forced to stand reluctantly in the doorway! (Sydney Smith)

Levisham Mill, seen from the footpath up to Lockton. The mill was owned at this time by Walter Hornby. (Sydney Smith)

A farmer driving his two-wheeled block cart up Rawcliffe Bank, between Stape and Newton-on-Rawcliffe. (Sydney Smith)

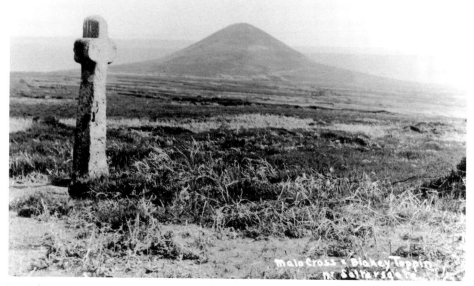

Malo Cross and Blakey Toppin, near Saltersgate. This open moorland landscape has since been planted with trees by the Forestry Commission. (Sydney Smith)

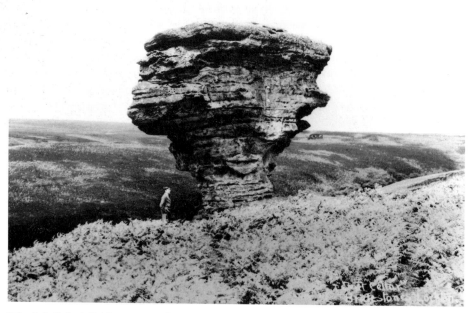

'The Salt Cellar', Bridestones, Lockton. Edmund (Eddie) Smith, son of Sydney, is standing under the best known of the outcrop of rocks called the Bridestones. They are situated east of Saltersgate on the Whitby road and now form part of a nature reserve.

Two
Portraits

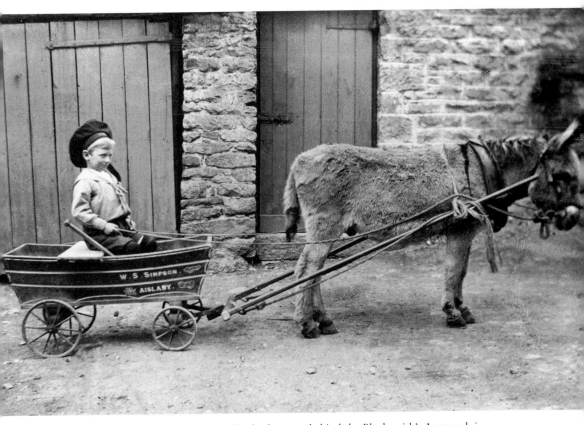

William Stanley Simpson, sitting in his donkey cart behind the Blacksmith's Arms pub in Aislaby. He was born in 1905 and died in 1966. (Photographer unknown)

William Stanley Simpson on his black horse. Again, this is by the pub: note the empty bottles and beer crates behind the horse. William's father, William Agar Simpson (1865-1947), was the innkeeper until 1919. His mother was Emma Simpson (1875-1946). The inn has now closed, and will be converted into dwellings. (Sydney Smith)

Mrs Mary Mackley of Glebe Farm, Saltersgate, is being asked to fill a tea can for William (Tweet) Humble of Pickering. William lived in Pickering but would travel to the villages, calling at farms for refreshments. (Photographer unknown)

Ida May Scott (*née* Sherwood) in her Salvation Army uniform. She lived in Pickering and later worked in the Central Cinema in the town as an usherette. (Photographer unknown)

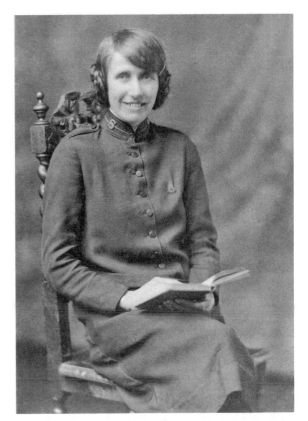

Moses Morley of Cropton, outside his cottage. He was a joiner and implement and clock maker; he also made and sold rocking washing machines. One of these machines and some of his tools can be seen in Beck Isle Museum. (Photographer unknown)

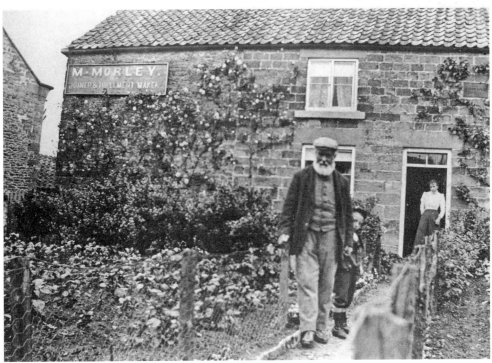

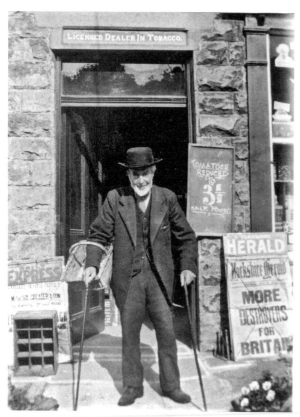

Hundred-year-old Robert Brisby of Wrelton leaving Welford's village shop in 1936. He died on 11 July 1937. Robert worked all his life in agriculture, starting at the age of twelve, and farmed at Cass Hagg Farm in Wrelton for fifty years. He was always interested in public life and was a way warden under the old Highways Act. He served on Pickering Rural Council and the old Board of Guardians for thirty-two years and later became chairman of the council. He was also a local Methodist preacher for seventy-five years. The newspaper headline in the background reports the big rearmament programme in the years before the Second World War.
(Hilda Mary Welford)

An unknown gipsy woman smoking a clay pipe. (Sydney Smith)

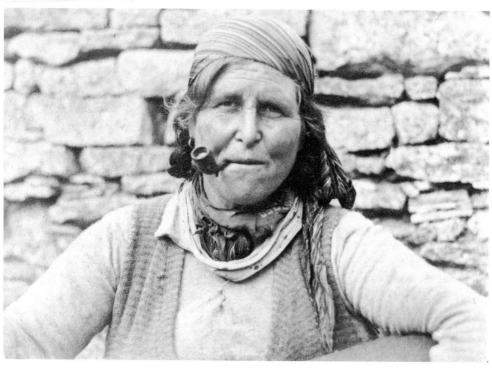

A brilliant portrait of Mr George Smith of Dukes Lea Farm, Hartoft, with his dog, Jean. (Sydney Smith)

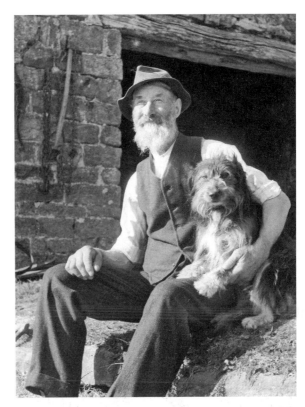

Daniel Duffield Turnbull ('Dan Duff') holding his horse outside the Blacksmith's Arms pub in Aislaby. The date of this picture is probably around the time of the First World War; Daniel was born in 1869. (Sydney Smith)

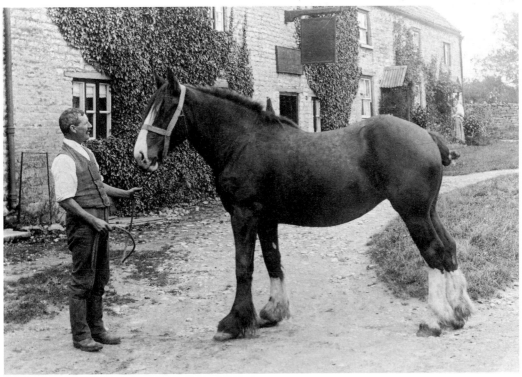

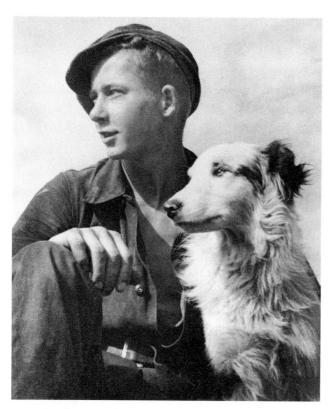

Doug Wilson of Melrose Farm, Newton-on-Rawcliffe, is seen posing with his sheepdog on his farm. (Sydney Smith)

Rozann Sherwood from Newbridge Cottages, Pickering, admires the wild flowers on the quarry tops, above Newbridge. (Sydney Smith)

Three grey horses – Pansy, Daisy and Violet – in 1938. They were owned by Mr Charles Braithwaite of Corner Farm, Wrelton, who named all his horses after flowers. They are seen here in a field called the Shoulder of Mutton, between Aislaby and Wrelton. (Sydney Smith)

'A Yorkshire cowboy': Mr Herbert Hesp, of Newton-on-Rawcliffe. (Sydney Smith)

Doug Wilson of Melrose Farm, Newton-on-Rawcliffe, holding his horses, Royal and Tom. (Sydney Smith)

Tom Warriner, farmer and former gamekeeper, with his dog, Darkie, in January 1940. He lived at Bar Farm, Saltersgate. (Sydney Smith)

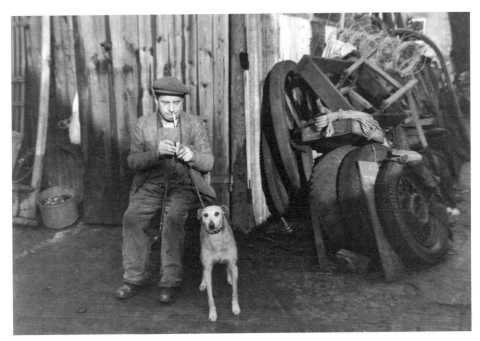

Pickering wheelwright Richard (Dickie) Dale lights a cigarette during a break from work in 1954. He had a joiner's shop in Eastgate. His whippet was called Punch. (Gordon Clitheroe)

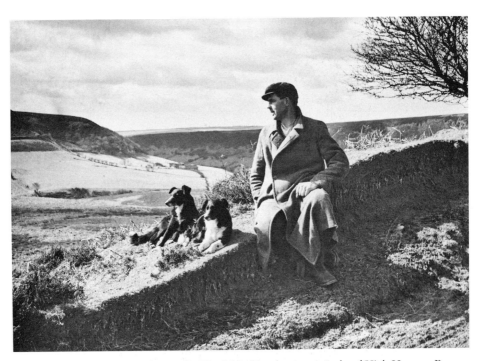

'The Dalesman': a portrait of Mr John Ward Mackley, known as Jack, of High Horcum Farm, with his sheepdogs Lassie and Gypsy. In the background is the Hole of Horcum, above Jack's farm. The photograph dates from between 1949 and 1953. (Sydney Smith)

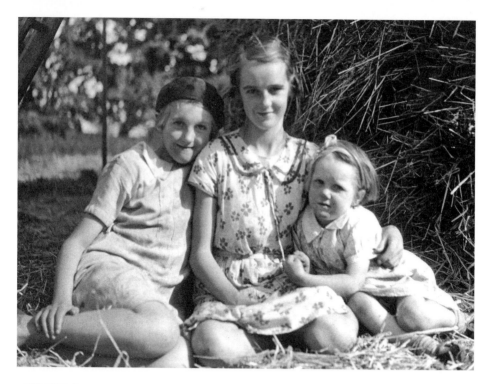

Sisters Sheila, Kathleen and
Joan Mitchell sitting in front
of a straw stack at Yatts
Farm, Newton Road, near
Pickering, in 1939.
(Sydney Smith)

Rozann Sherwood of
Newbridge Cottages poses
with a sheaf of corn. She
would have had to hold the
corn until Sydney Smith had
taken numerous photographs
to obtain the desired result.
Her payment for the work
was sixpence!
(Sydney Smith)

Three
Village Streets and Buildings

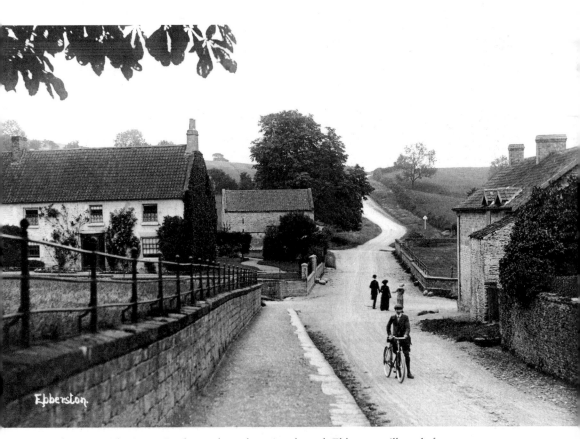

The main Pickering to Scarborough road passing through Ebberston village, before 1914. (Sydney Smith)

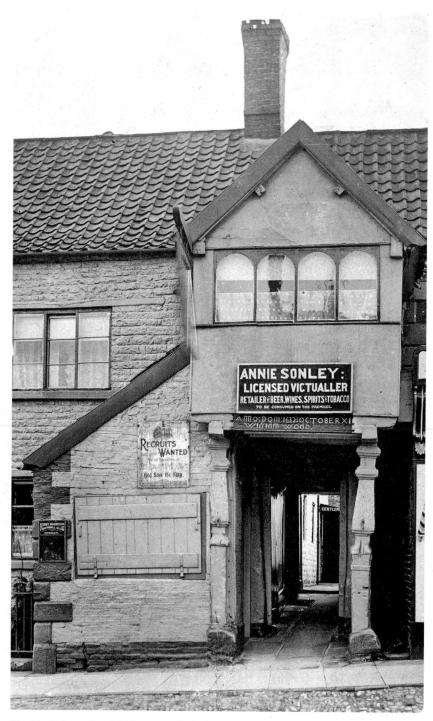

The Black Swan Inn, Kirkbymoorside, before 1908. Annie Sonley was the licensee. The sign to the left of the passage reads: 'Recruits wanted for all branches of His Majesty's Army. God Save The King.' The Inn has now been changed into a Tandoori Indian Restaurant. (Lealman, Kirkbymoorside)

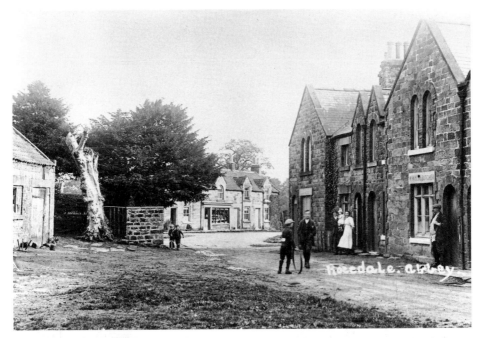

Bridge Street, Rosedale Abbey. On the right is Billy Welsh the butcher standing in his shop doorway. The house next to the shop on the left was known as Odd End. (Thought to be by William Hayes)

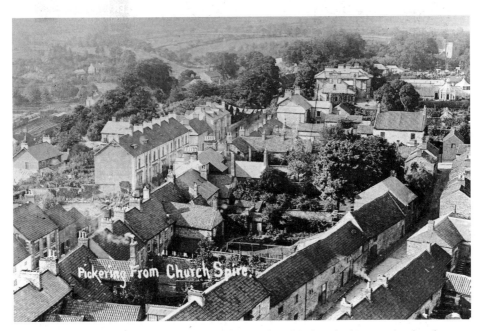

Sydney Smith took this photograph of Castlegate, Pickering, after climbing up the church tower in 1911. The High Hall, home of the Mitchelson family, can be seen in the background. Flags are flying across the street: this may be in celebration of George V's Coronation, which occurred that year. The hall was later demolished and Rosamund Avenue now occupies the site. (Sydney Smith)

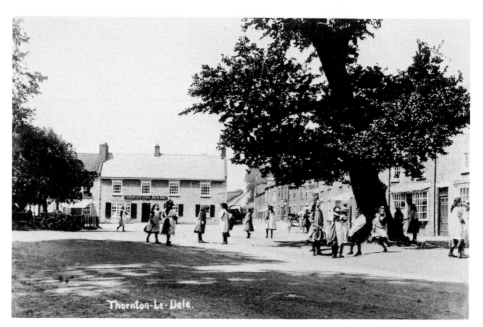

Girls from the school in Thornton-le-Dale playing on the main road to Scarborough and around the big elm tree. The tree was removed in 1984 after succumbing to Dutch elm disease. The owner of the New Inn, on the left, was J. W. Marflitt. (Sydney Smith)

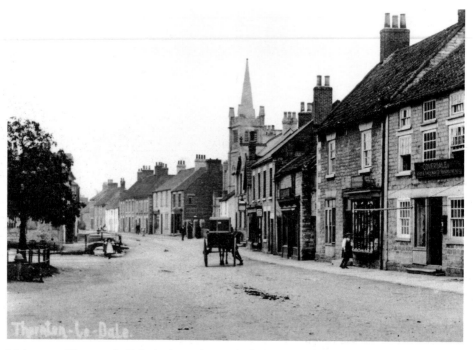

Maltongate, Thornton-le-Dale, in the early twentieth century. Coverdale's shoe shop is on the right, next to Wardill's shop. The road is still unsurfaced, with heaps of horse manure here and there. (Sydney Smith)

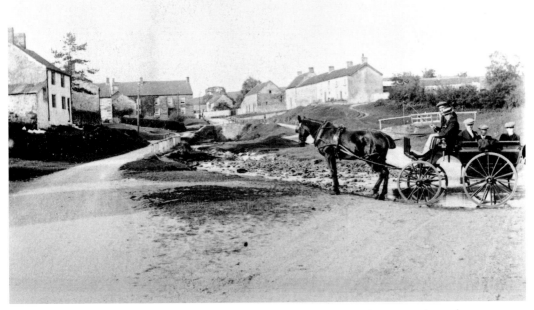

A party of men rest their pony after a trip by four-wheeled cart to Hutton-le-Hole. The water-splash was later piped under the road during carriageway improvements. (Sydney Smith)

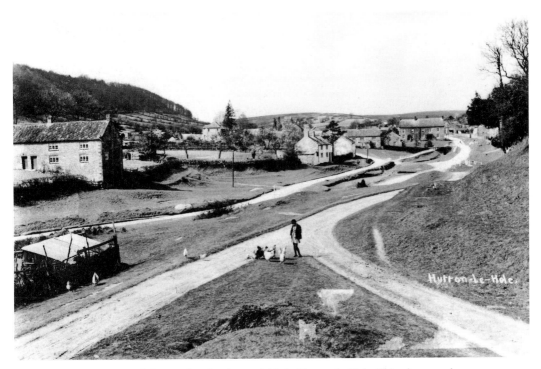

A young woman with her poultry by the roadside in Hutton-le-Hole. This photograph was taken before the fords were bridged and before any tourists arrived. (Sydney Smith)

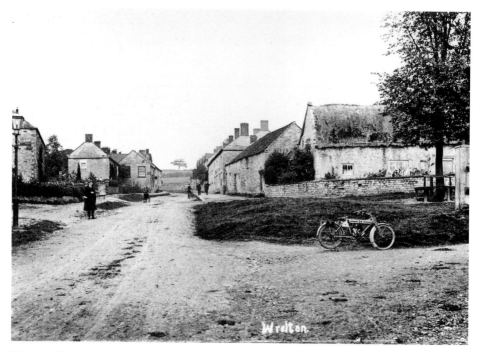

Wrelton village green, showing the water pump (extreme right) and an old motorcycle (registered AJ993) in the foreground. On the right is a cottage with a thatched roof, which has since been demolished and replaced. (Sydney Smith)

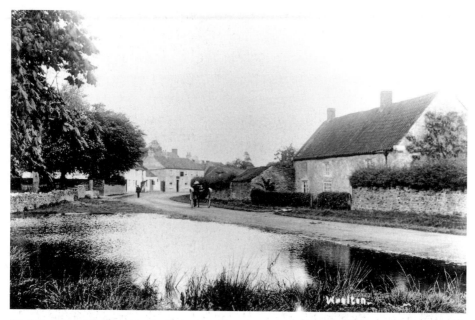

Wrelton village. The pond in the foreground has since been back-filled. Two ladies are riding into the village on a pony and trap on the main Kirkbymoorside to Pickering road. The Buck Inn is in the middle of the picture. The road is quiet again, as the village now has a bypass road. (Sydney Smith)

Newton-on-Rawcliffe village, with geese on the bottom pond. This pond was filled in 1949, but a second pond has survived a little further up in the village. (Sydney Smith)

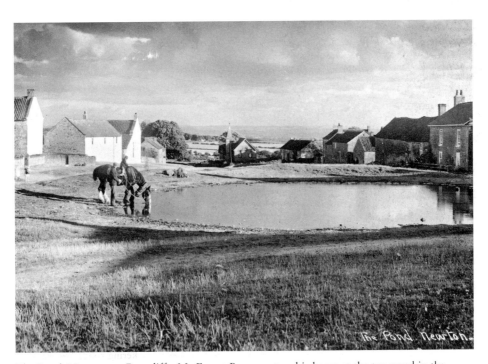

The Pond, Newton-on-Rawcliffe. Mr Ernest Boyes waters his horse at the top pond in the village. His son, Phillip, is sitting on the horse. (Sydney Smith)

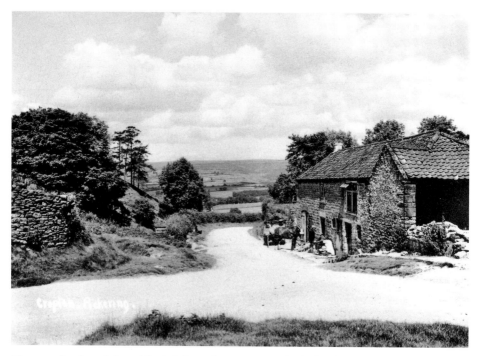

Men pass the time of day while their horse has a rest outside the blacksmith's shop at the top of Cropton Bank. The blacksmith was Les Aconley, who moved to Cropton after the closure of the Rosedale ironstone mines. Les had been employed shoeing pit ponies in the mines. (Sydney Smith)

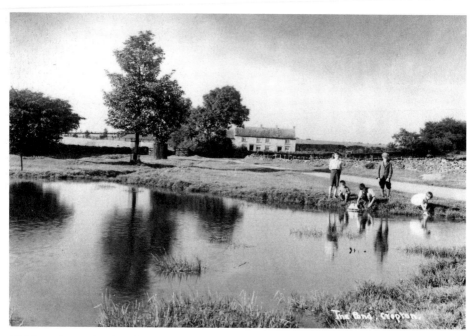

Children play with sailing boats on 'Dams' Pond at the top of Cropton village, which has since been filled in. (Sydney Smith)

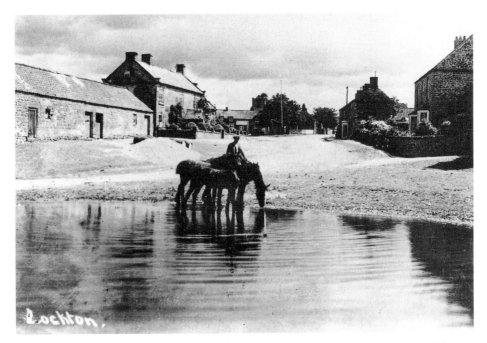

Mr George Hardcastle of Newton-on-Rawcliffe with Thomas Robinson's horses Bonny, Tiny and Little Bonny as they drink at Howl Head Pond, Lockton. The pond has since been filled in. George Hardcastle was born on 12 September 1915 and joined the Army when he was twenty. (Sydney Smith)

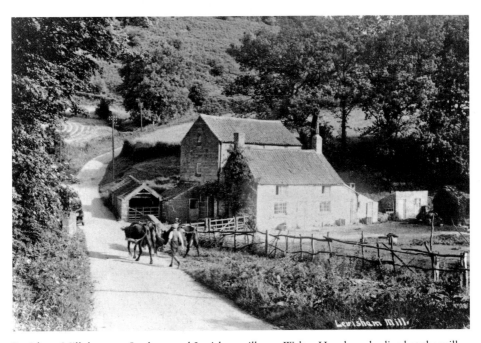

Levisham Mill, between Lockton and Levisham villages. Walter Hornby, who lived at the mill, is returning home with his cows. (Sydney Smith)

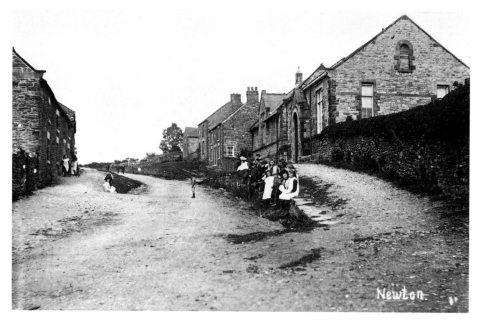

Newton's schoolchildren sit and play outside the village school, the building on the right of the photograph. Note the stony, unsurfaced road and footpath. The school is now the village hall. (Sydney Smith)

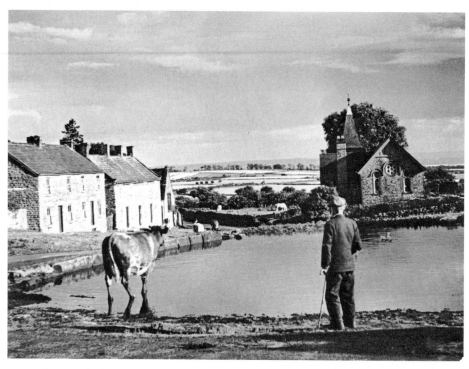

Mr Herbert Hesp of Newton-on-Rawcliffe, watching his cow drinking at the bottom pond in the village. This is the pond that was filled in in 1949.

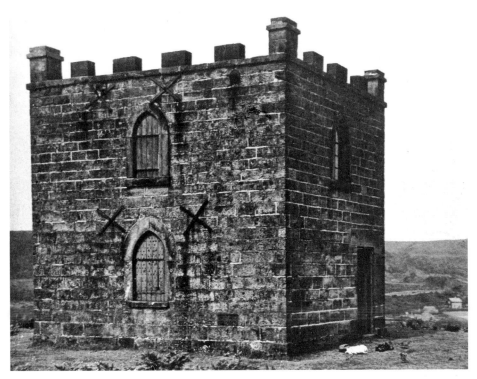

Skelton Tower, near Saltersgate. This shooting lodge was built by Revd Skelton of Levisham, who used it to escape from his wife and children and to write his sermons. The trilby hat and other items to the right of the tower belong to Sydney Smith. (Sydney Smith)

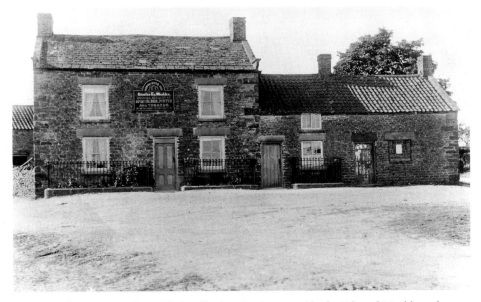

The Horseshoe Inn, Levisham. The landlord at the time was Charles Edward Mackley, who was a retailer of spirits, beer, porter and tobacco. (Photographer unknown)

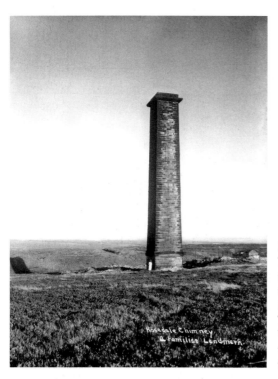

Rosedale Chimney – a familiar landmark. The chimney was part of the power house at the Rosedale ironstone mines which was used to pull fully loaded trucks of iron ore up an incline, to be burnt at the kilns at the top. The chimney was demolished in 1972 by Mr Wardle Darley, Lord of the Manor, because it was unsafe. Maud, Sydney Smith's wife, is at the base of the chimney. (Sydney Smith)

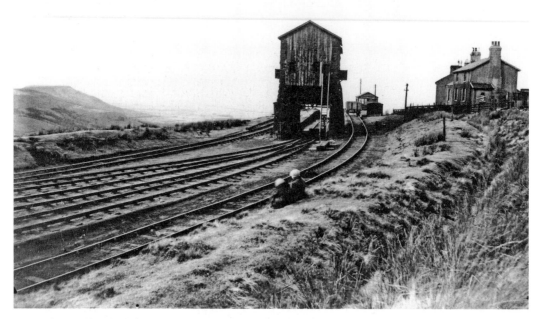

The winding sheds and cottages at the top of Ingleby Incline, on the Rosedale ironstone railway. The drum house on the left allowed fully laden trucks going down the incline to pull up the empty trucks. Sydney Smith's children, Barbara and Edmund, are sitting in the foreground. (Sydney Smith)

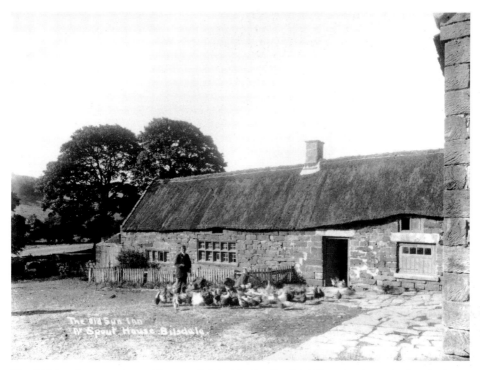

The Old Sun Inn, near Spout House, Bilsdale. The landlord, William Ainsley, is feeding his hens in front. The old pub has two pairs of wooden crucks, a cross-passage, beehive oven and box beds. It was restored a few years ago by the National Parks Authority. (Sydney Smith)

The White Swan Hotel, Newton-on-Rawcliffe. The old car in front of the pub seems to date the picture to the Edwardian period. (J. W. Malton)

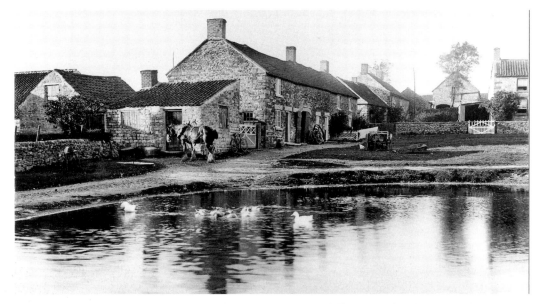

The blacksmith's shop by the top pond in Newton-on-Rawcliffe, with a Shire horse outside. (Sydney Smith)

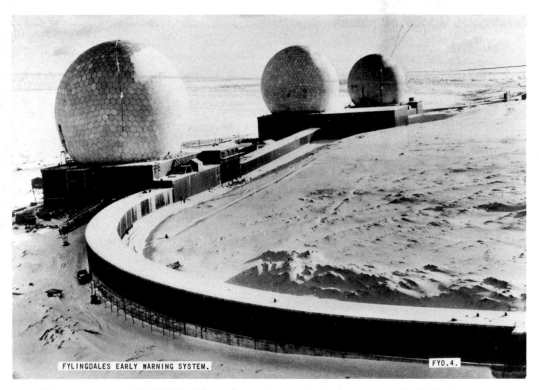

FYLINGDALES EARLY WARNING SYSTEM. FYD.4.

The construction of RAF Fylingdales early warning station in the 1960s on the Pickering to Whitby road. The three golf ball-like radomes were demolished in the 1990s and replaced by a single large triangular building. (Photographer unknown)

Four
People at Work

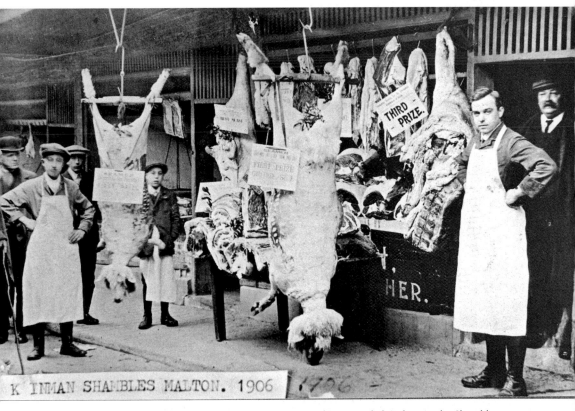

Butcher K. Inman (on the right in the white apron), standing outside his shop in the Shambles, Malton, in 1906. He is displaying carcasses of animals that have won prizes at the Seamer livestock market. (Photographer unknown)

Rosedale Abbey schoolgirls posing with their teacher, dressed in their Sunday best.
(Photographer unknown)

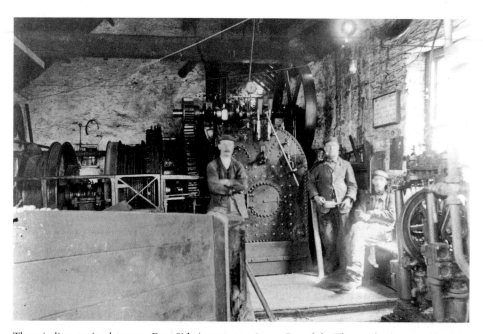

The winding engine-house at East Side ironstone mine at Rosedale. The workmen are
C. Hopwood, Sam Walker and G. Moles. The winding house was used to pull railway trucks up
an incline. The photographer, Thomas Smith, was a Rosedale boy who became a cinema owner
and photographer in Middlesbrough. He was born on 14 April 1878.

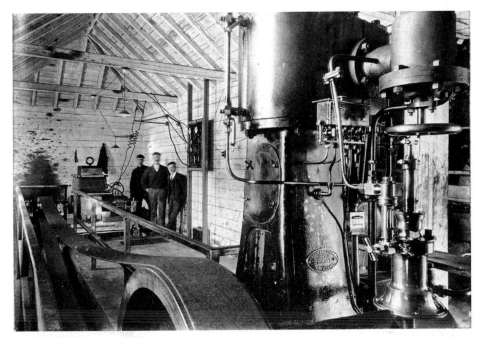

An electricity generator at the East Side mines, Rosedale East, in 1910. It was installed by the Carlton Iron Company in 1900; it was made by Ruston Proctor & Co. Ltd of Lincoln, no. 21161. The workers are, from left to right, Tom (?) Woodhouse, C. Hopwood, Alf Smith (who moved to Canada before the First World War). (Thomas Smith)

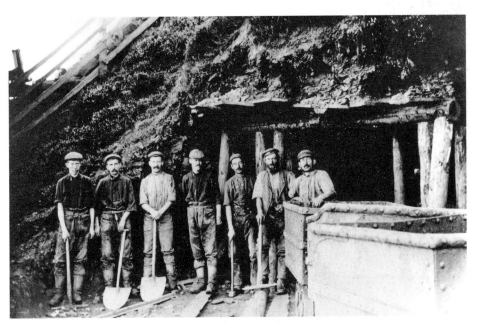

Sherriff Pit miners at the drift entrance above Medds Farm, Rosedale West. Men and empty trucks used this entrance and then the fully loaded trucks of iron ore were lifted vertically out of the mine. (Thomas Smith)

Building workers thought to be from W. Anelay of York, working on Keldy Castle near Stape in 1910. The castle grounds were used for many years as a venue for Stape Show. The house was demolished in the 1950s and is now the site of holiday cabins owned by Forest Enterprises. The only man so far identified is Seth Coverdale, in the white coat fourth from the right on the back row. He was born on 13 March 1893 and died on 9 November 1964. (Sydney Smith)

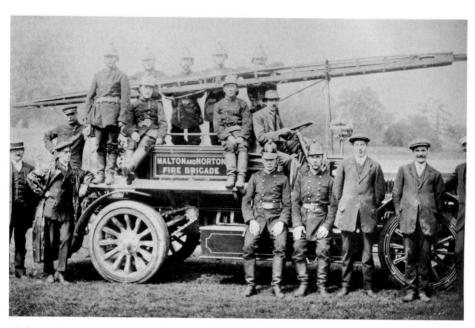

Malton and Norton Fire Brigade pose with their first motor fire engine. It is thought to have been named *Countess Fitzwilliam* and was bought in 1914 for £1,100. The driver, who was also the fire chief, was Lorrie Thackray. (Photographer unknown)

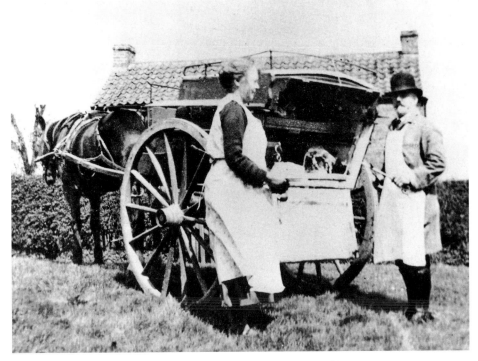

Travelling butcher Albert Bradshaw of Lund House, Amotherby, selling meat to a customer from the back of his butcher's cart. His brother was also a butcher in Malton. (S. M. Jameson)

This rare photograph shows an undertaker collecting a coffin with his hearse and two horses from the Waggon and Horses Inn (later the Saltersgate Inn) on the Pickering to Whitby road. Other people stand in the road to pay their respects. The date and details of the deceased are not recorded. (Photographer unknown)

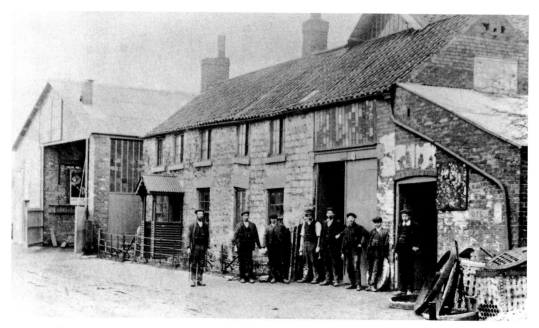

Workmen standing outside the engineering workshops of Thackray's of Brawby, near Malton. (Photographer unknown)

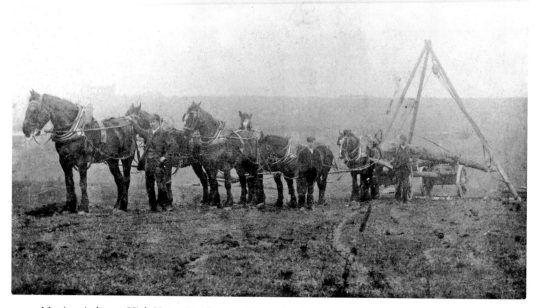

Moving timber at High House, Lockton, with a pole wagon and six horses. The contractors are Franks Timber Merchants of Irish Hall, Pickering, and the man at the front with the horses is William (Billy) Hogarth. (Photographer unknown)

Bob Hewitt, the bellman of Kirkbymoorside for over thirty years, rings his bell near the Black Swan in the market place. The caption on the picture reads 'Kirbymoorside' although the town is now spelt with the extra 'k'. (William Hayes)

The village road-sweeper with his wooden barrow at the bottom of Thornton-le-Dale High Street (now the main road from Pickering to Scarborough). The white thatched cottage on the right is called Dog Kennel Cottage. Note the cast-iron standpipe on the right-hand verge: this was the only supply of clean drinking water for people without a piped water supply, but it had to be collected in buckets. (Sydney Smith)

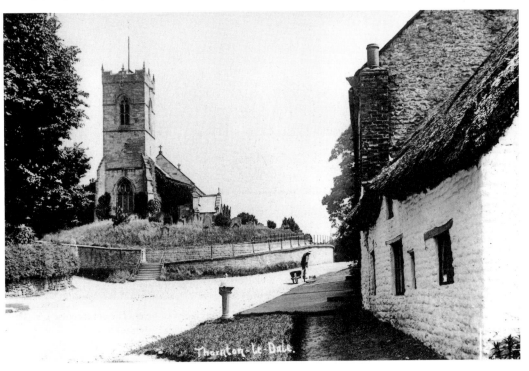

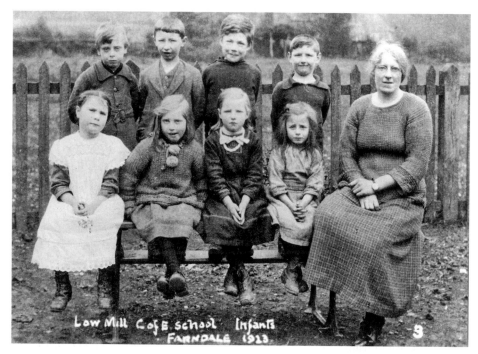

Low Mill Church of England School infants, Farndale, in 1923. From left to right, back row: Harry Wilson, John Ibbotson, Herbert Cook, William Ibbotson. Front row: Tarnor Tinsley, Dorothy Brown, Elizabeth Ford, Martha Wilson, teacher Annie Maw. (William Hayes)

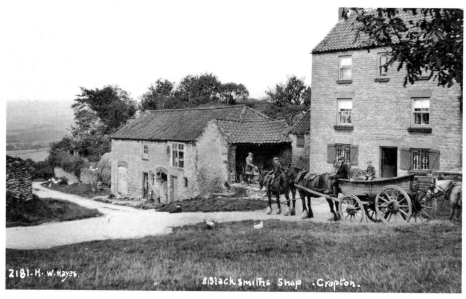

The blacksmith's shop at the top of Cropton Bank in 1924. Isaac Grey, the blacksmith, is standing by the grindstone; J. W. (Bill) Stephenson is sitting on the front horse; and the wagon-driver is Bob Berriman. The boy on the wagon is George Stephenson. Isaac Grey later emigrated to Canada. (William Hayes)

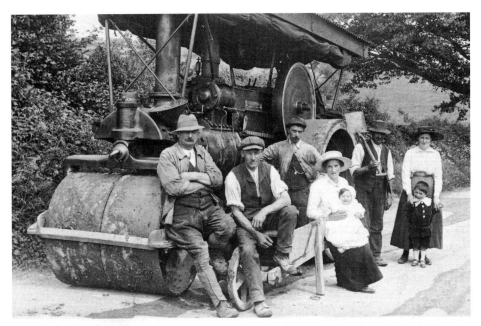

Pickering Council's steam roller at rest during road works on Cropton Lane, Wrelton, in the 1920s. From left to right: William Agar Simpson, -?-, George Newman (driver, with watch chain), Mrs Newman with baby Alice, Mr and Mrs McLaren with Alfred Newman. The roller, a 10-ton engine, number 1461, was built by T. Green of Leeds and was delivered new in 1901, possibly to Pickering RDC. By 1926 it was in the possession of John Thackray of the Rye Valley Works, Brawby. (Photographer unknown)

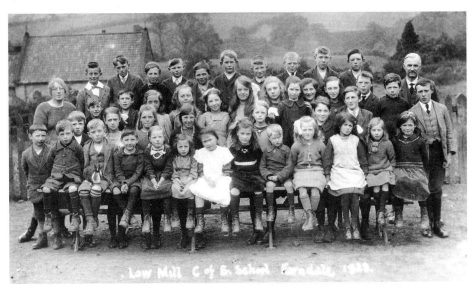

Low Mill Church of England School, Farndale, 1923. The teacher at the left of the back row is Annie Maw; next to her is John Ibbotson. The teacher at the right-hand end is Mr Brown and the lads third and fourth from the right at the back are Herbert Breckon and Fred Wass. The only other known person is William Ibbotson, third from the left on the front row. (William Hayes)

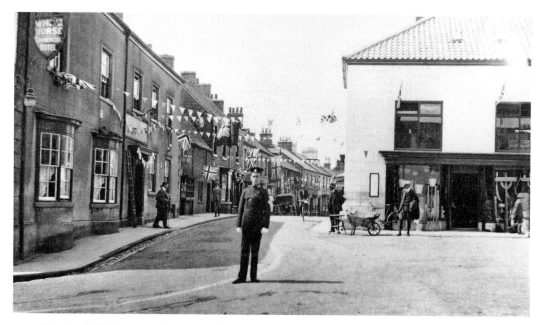

West End, Kirkbymoorside, with a policeman on duty, 31 July 1925. The decorations are in honour of the royal opening of the Adela Shaw Hospital in the town. The White Horse commercial hotel is on the left and Cooper's ironmongers is on the right. (William Hayes)

Workmen cutting timber at Farndale, using a traction engine to drive the saw bench. (Photographer unknown)

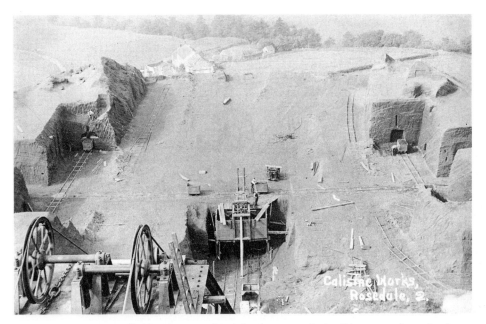

This tramway was installed by T. W. Ward Ltd for the removal of calisine waste from the tip at Rosedale East mines after the mines had closed down. The processing of waste became viable in the 1920s; this photograph dates from 1927. (Sydney Smith)

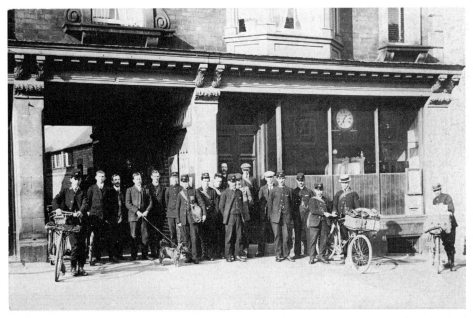

Pickering postmen and post office workers outside the post office in the market place. The post office has since closed and is now a chemist's shop. From left to right: Ernest Hubbard (With bicycle), Tom Taylor, -?-, the postmaster (either J. J. Green or Mr Fletcher – with dog), -?-, -?-, William Maymen (With post bag). The rest are unknown except for the man in the boater, who is Tom Jackson. (Photographer unknown)

Pupils of Pickering Wesleyan School in 1927. From left to right, back row: headmaster Mr Skelton, -?-, -?-, ? Fenwick, Leslie Gaines, -?-, -?-. Middle row: all unknown except for the tall boy in the middle, who is Henry Townend. Front row: Phillip Wood, Olive Headley, Joan Crawford, Elsie Smith (holding the board), Doreen Maud, -?-, -?-. (Photographer unknown)

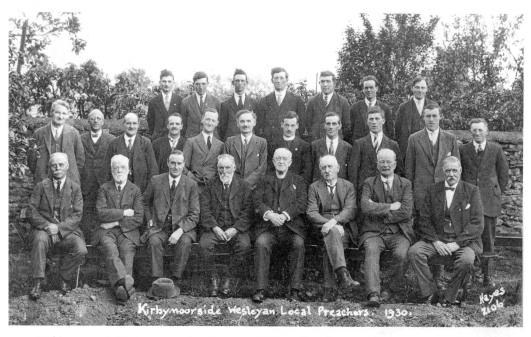

Kirkbymoorside Wesleyan preachers in 1930. (William Hayes)

Saltersgate School pupils outside their school in 1932. The building was on the Pickering to Whitby road just before the Saltersgate Inn. After it was demolished, the stone was used to build a nearby farmhouse. The school was used as a chapel at weekends. From left to right, back row: Walter Mackley, Ada Watson, Ida Warriner, Mary Pennock, Doris Lloyd, Annie Mackley, Miss Highfield (teacher). Front row: Christine Lenard, William Lenard, Harry Lenard, Ivy Watson, Edith Lenard, Leslie Harrison, Norman Watson. (Photographer unknown)

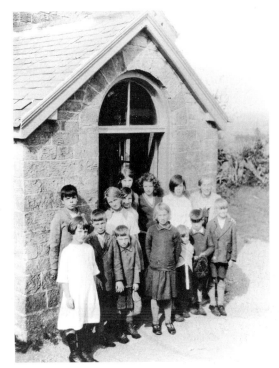

William McGuire, a travelling basket maker. He travelled around the villages near Malton selling his baskets for a number of years. (Photographer unknown)

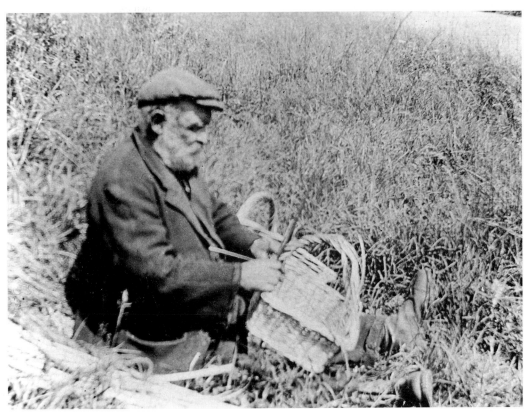

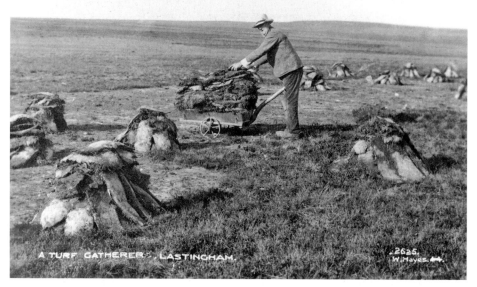

A man with a small handcart gathers turves at Lastingham. The slabs of peat have previously been cut from the ground and stacked up to dry, and can now be used for fuel. (William Hayes)

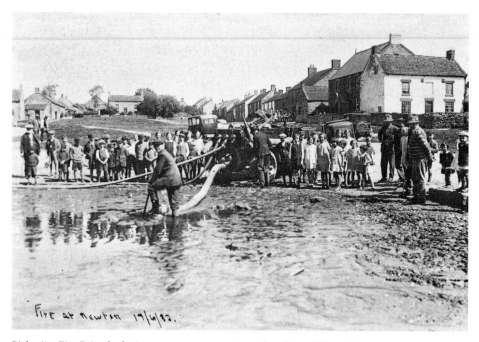

Pickering Fire Brigade during an attempt to extinguish a fire at Manor Farm, Newton-on-Rawcliffe, 19 June 1932. They are being watched by local schoolchildren. The brigade ran out of water after emptying both ponds, as the village had no mains water supply. (Sydney Smith)

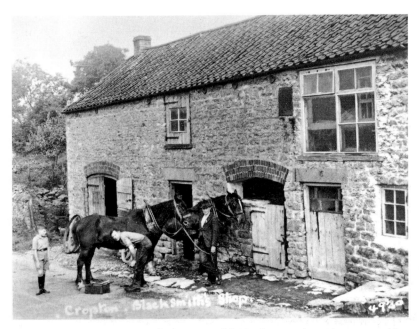

Cropton blacksmith George Hill (from Rosedale) is about to shoe a horse owned by Feasters of Cropton. The labourer is Herbert Norminton and the boy in the road is Eric Croot. The forge was at the top of Cropton Bank and George Hill was the last blacksmith to operate it; he took over from Les Aconley in 1938. (William Hayes)

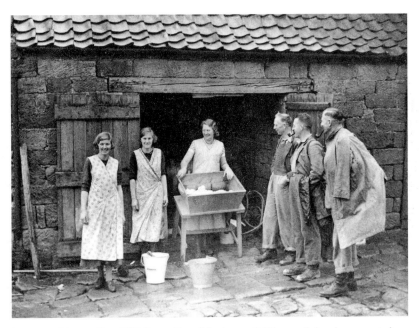

Butter making at Cote Hill Farm, Farndale, in 1938. The work has been carried out by Caroline, Annie and Lillie Wheldon, to the approval of passing hikers Alec Falconer, Jim Murray and Alec Wright. (Photographer unknown)

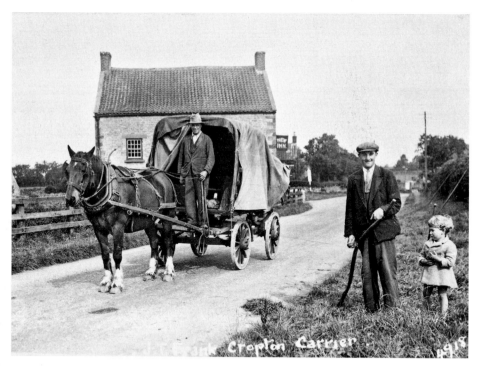

Jack Frank, a Cropton carrier, photographed near the New Inn at Cropton in 1939. Henry Peirson, a council roadman, stands on the verge with Peter Croot, the small boy. (Raymond Hayes)

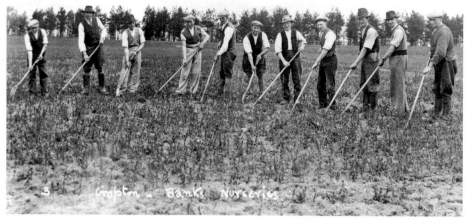

Forestry workmen hoeing weeds between young trees at the Cropton Bank Nurseries above Cropton village in 1940. From left to right: Ernest Farrow, Laurence (Lorrie) Bently, Robert (Bob) Pennock, Eric Fletcher, Alfred Eddon, Tom Pickering, William Hammond, John Roberts, John Wood, George Stephenson, Fred Spengley. (Sydney Smith)

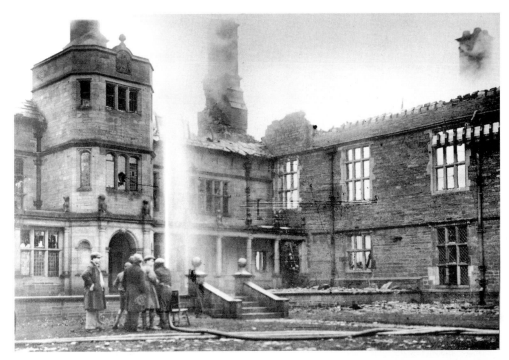

A fire broke out on 1 February 1931 at Welburn Hall, near Kirkbymoorside, the home of Major John Shaw and his wife. Pickering Fire Brigade arrived at the scene under the command of Supt Pickering and the Malton Fire Brigade assisted under the command of Supt Knife. The river Hodge that runs through the grounds provided a supply of water and was pumped onto the fire for eight hours. However, when the flames were extinguished only the shell of the hall was left standing. The cost damage was estimated at £50,000 – the building was almost totally destroyed. The hall was later rebuilt by E. Priestley. (Sydney Smith)

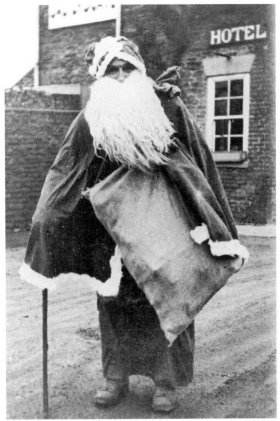

Father Christmas (in the form of Fred Warriner of Bar Farm, Saltersgate) outside what was then known as the Saltersgate Hotel on the Pickering to Whitby road. It is believed that the photograph was taken in the 1940s. (Photographer unknown)

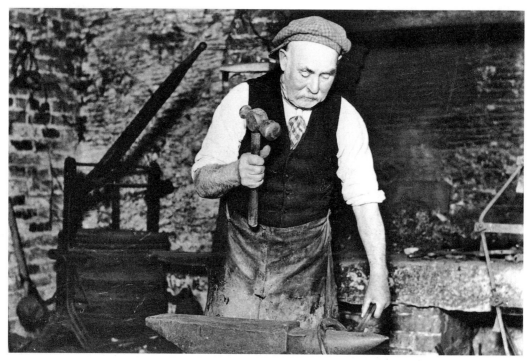

Blacksmith Mr Bowes at work at Great Barugh forge, making a horseshoe.
(Photographer unknown)

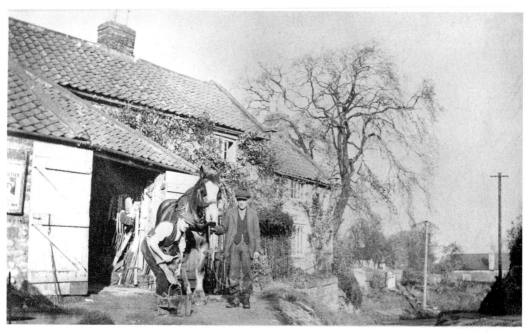

A blacksmith shoeing a farm horse at the forge in Barton-le-Street. The forge has since closed
and is now a cottage. (Photographer unknown)

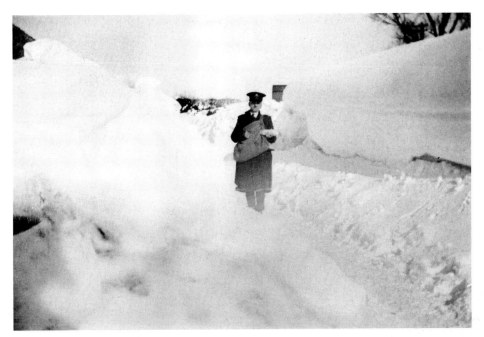

Pickering postman Sam Brewer delivering mail through the snowdrifts at the top of Newton-on-Rawcliffe village in the winter of 1947. (Photographer unknown)

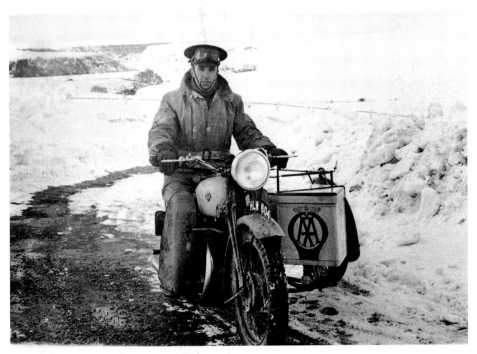

Mr Tom Hodgson, an AA patrolman from Pickering, on duty at Saltersgate on the Pickering to Whitby road during the harsh winter of 1946/47. He was known to his friends as Jock. (Sydney Smith)

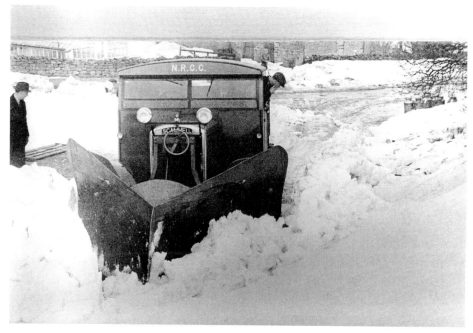

North Riding County Council workmen with a Scammell lorry and snow plough opening up a road in Lockton village. Note the milk churns awaiting collection on the right of the photograph. (Sydney Smith)

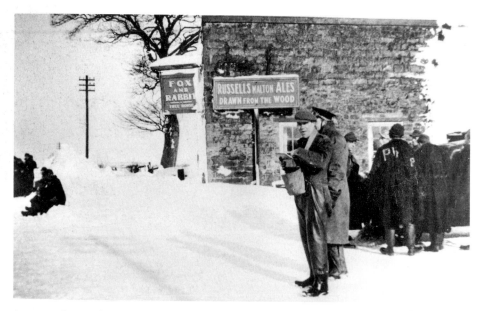

A group of men take a rest from snow cutting at the Fox and Rabbit pub on the Pickering to Whitby road in 1947. In the foreground is Ted Hitchcock opening his lunch box. Behind him is Tom Hodgson, the AA patrolman, and a group of German prisoners of war who had been working to clear the main road of snow. (Photographer unknown)

Five
Farming

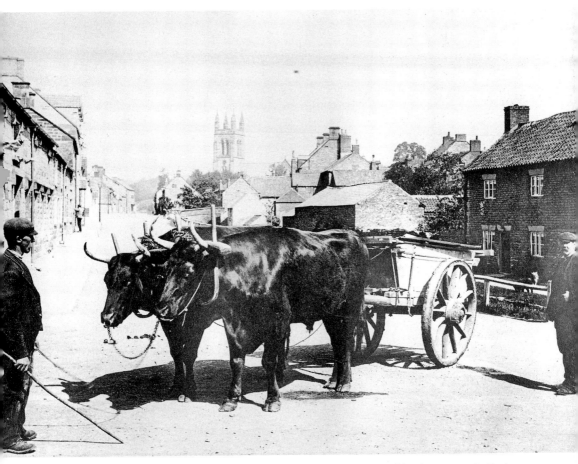

Oxen yoked to a two-wheeled block cart in Helmsley. They were owned by the Duncombe Park Estate and stabled at Griff Farm, near Helmsley. (Photographer unknown)

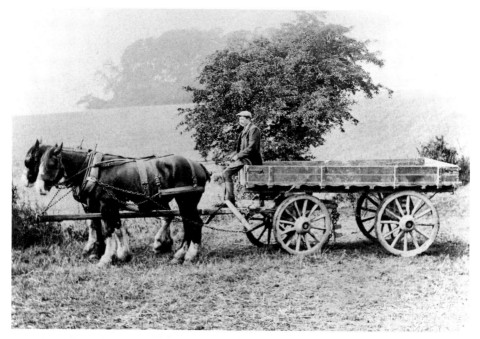

An unknown farmer with two horses and a pole wagon, seen near Kingthorpe on the Pickering to Whitby road. (J. W. Malton)

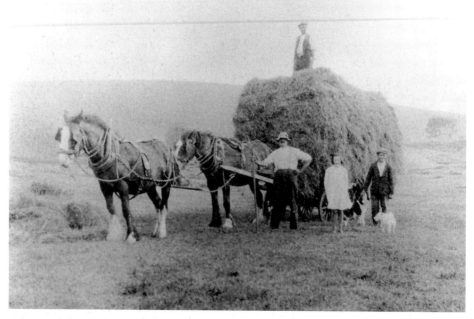

Haymaking at Saltersgate, on the Pickering to Whitby road. Tom Warriner is standing with his horses Doll and Daisy (behind, in the shafts). His son Fred is standing on the hay. Also pictured are his daughter Ida (who died aged twelve) and Edwin Warriner, with a dog called Queen. The photograph was taken in 1931 or 1932. (Photographer unknown)

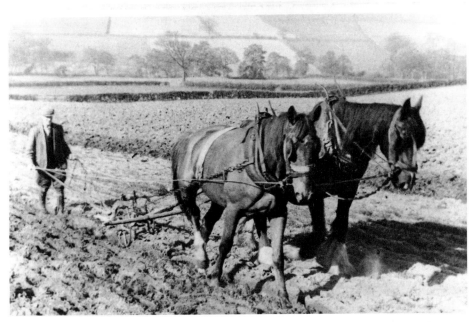

Lance Maw ploughing with two horses at Long Causeway, Farndale. (Photographer Unknown)

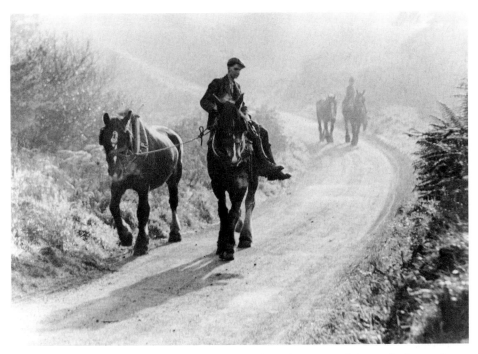

Ron Brisby, aged seventeen, of Grange Farm, Saintoft, leads Prince and Beaut, the front pair of horses, in 1934. Fred Harland, the owner, is with the back pair, called Charlie and Punch, returning from a day's work. (Sydney Smith)

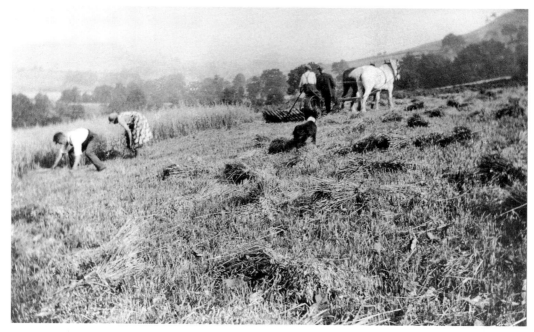

Cutting corn in Farndale in 1924. Lance Maw is driving the horses, James Watson is 'putting off' on the reaper and Jack Dale and Mary Maw are tying up the corn ready for stooking. (Photographer unknown)

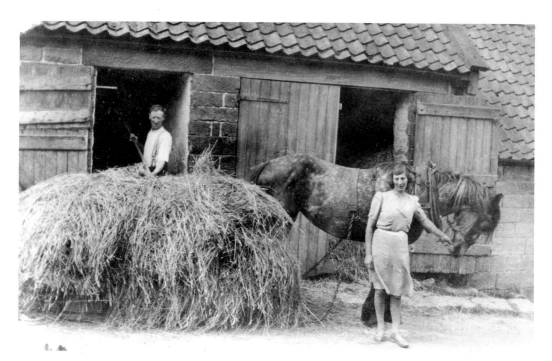

Lance Maw supervising the hay raking at Long Causeway, Farndale, in 1935. Mary Maw is holding the horse. (Photographer unknown)

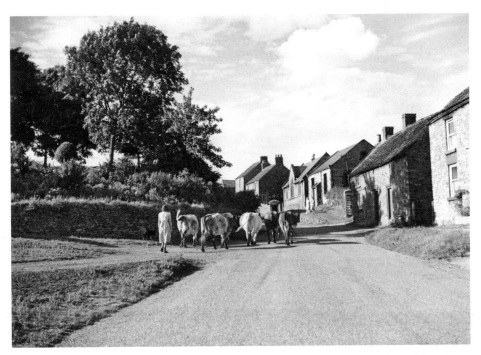

The epitome of village life: Mabel Boyes of Boon Hill Farm, near Newton-on-Rawcliffe, takes her cows home for milking. (Sydney Smith)

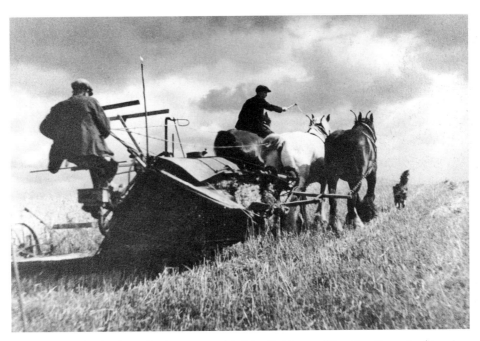

Harvesting with a binder at Lockton, 1935. Mr John Robinson of Box Tree Farm, Lockton, is riding the horse and his uncle Tom Robinson is on the binder. The sheepdog is called Ted. (Sydney Smith)

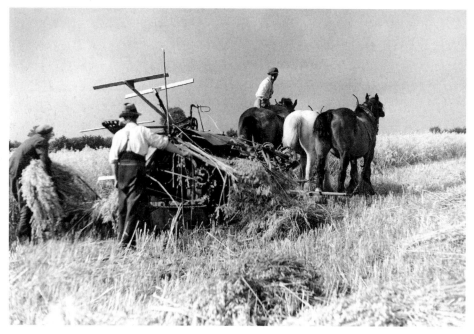

Harvesting at Lockton in 1936. Bert Eddon of Farwath is on the far horse, called Captain. Thomas Robinson (left, with flat cap) is holding a sheaf of corn and Herbert Dykes is standing behind the binder. The other two horses are Pedlar and Tidy. (Sydney Smith)

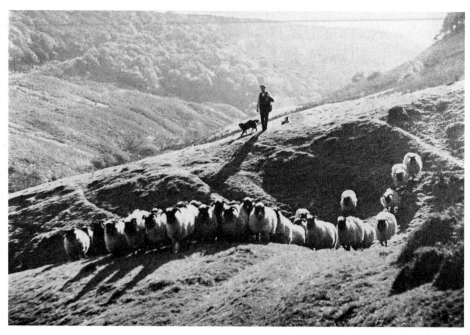

Mr William Henry Mackley of Low Horcum Farm, Saltersgate, gathering sheep in the early morning with his dogs Bess and Gyp, in 1935. Sydney Smith made numerous early-morning trips from Pickering to the Hole of Horcum in order to get this shaded study. (Sydney Smith)

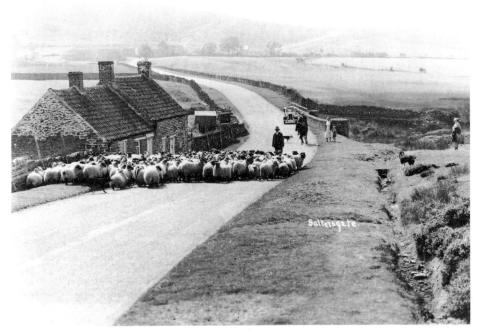

Mr Tom Warriner of Bar Farm is moving a flock of sheep near the old toll-house at Saltersgate. Sydney Smith's car is parked on the bridge. (Sydney Smith)

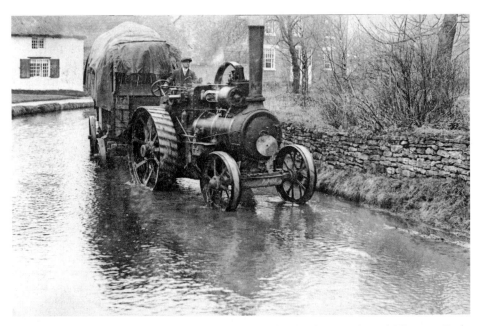

Mr John Armstrong of Prospect Farm, Wilton, driving his threshing set through Thornton Beck after threshing at Greens, Manor Farm, Thornton-le-Dale. He later moved to Great Edstone. The vehicle is a 6 hp single-cylinder Marshall engine, registration AJ7505, built in 1912. (Photographer unknown)

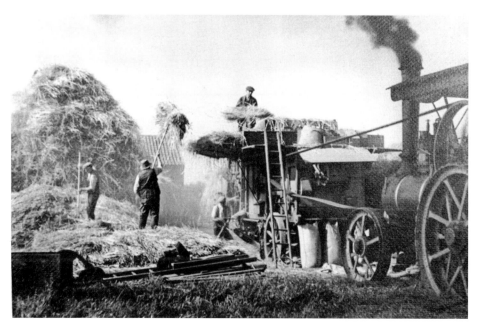

Threshing day at Mr Lister's, Tofts Barn Farm, near Black Bull, Pickering, in 1936. The threshing set, a Marshall, engine number 31093, was owned by Ralph Yates & Sons of Malton and was hired by the day. The engine was a single-cylinder 6 hp built in 1899, and was called 'Acme'. It was with Yates's by 1921 and was the only one of their engines to bear a name. Herbert 'Capt.' Carr is third from the left. (Sydney Smith)

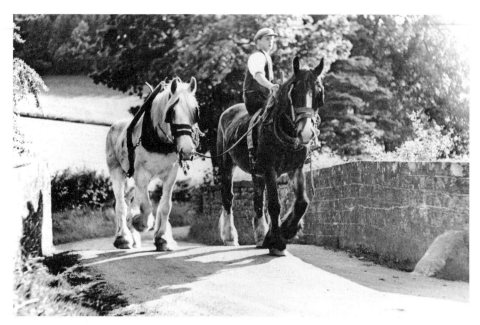

'Homeward bound' is the title given by Sydney Smith to this photograph from his 1938 series of countryside postcards. It shows Maurice Hesp with horses Pedlar and Charlie, owned by Tommy Smith of Low Askew, near Cropton. They are passing over Low Askew bridge. The picture was taken on 27 March 1938 and the farm was sold three days later. (Sydney Smith)

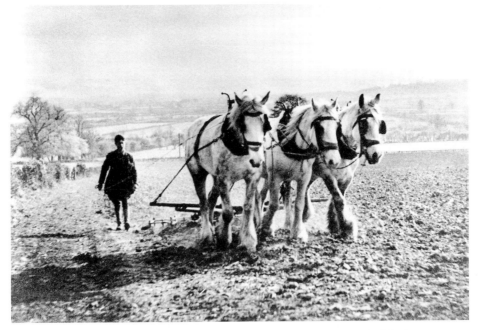

Eric Bowes of Pickering harrowing a field at the shoulder of Mutton near Aislaby in 1938. The three grey horses were called Pansy, Daisy and Violet and were owned by Mr Charles Braithwaite of wrelton. (Sydney Smith)

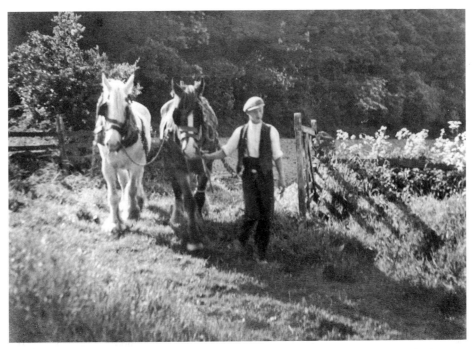

Maurice Hesp leaving a field at Low Askew, near Cropton, with horses Pedlar and Charlie. (Sydney Smith)

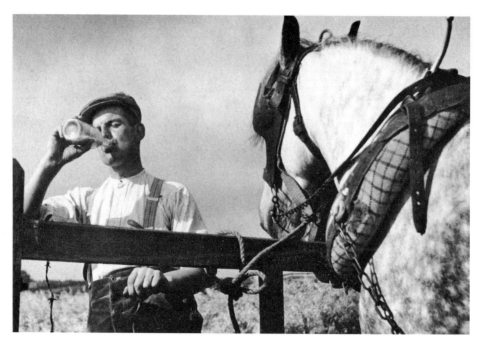

Mr Fred Peirson of Lockton enjoys a cold drink and gives his horse a rest at David's Lane End, in 1939. The horse, called Cobby, was owned by the Smith brothers of West View Farm. (Sydney Smith)

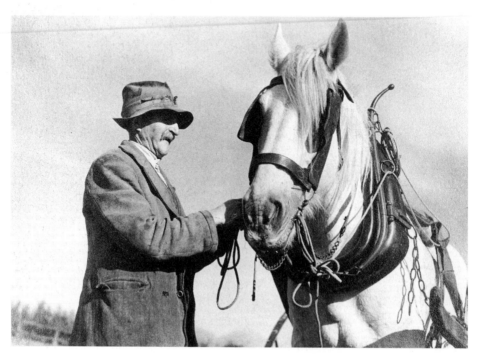

Mr Jack Hammond of Box Tree Farm at Lockton in 1939. The horse is called Pedlar. (Sydney Smith)

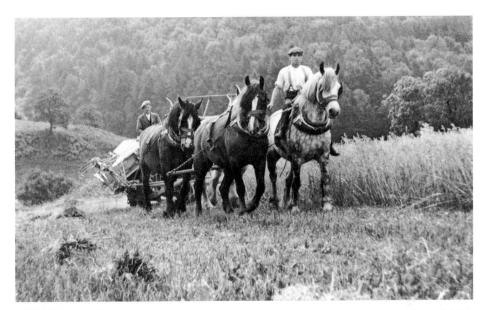

The Smith brothers of West View Farm, Lockton, pulling a binder with three horses in a field near Lockton. Thomas is on the binder, while George rides the horse (Cobby). (Sydney Smith)

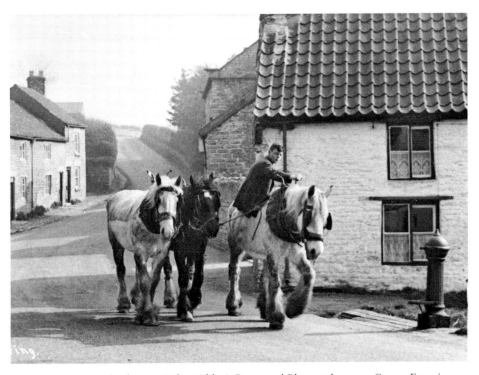

Eric Bowes bringing his horses Violet (ridden), Pansy and Blossom home to Corner Farm in Wrelton. On the right is standpipe for villagers not connected to the mains to obtain water. This part of the village is known locally as Goshen, a Biblical name meaning 'place of light or plenty' (see Genesis ch. 45, v. 10 and Exodus ch. 8, v. 22 and ch. 9, v. 26). (Sydney Smith)

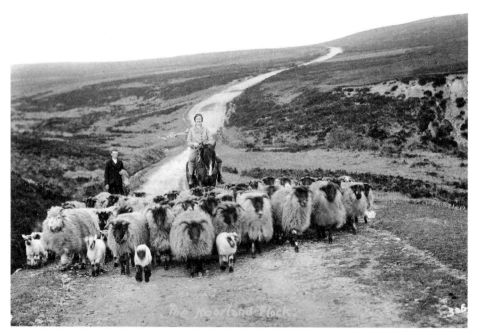

Rose Farrow of Hutton-le-Hole herding a flock of sheep above the village. (William Hayes)

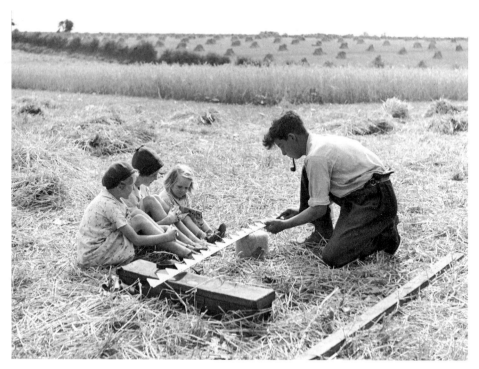

Bill Jemison sharpening a reaper blade at Jacklin's, Lydds Farm, near Pickering, during the harvest in 1939. Looking on are sisters Sheila, Kathleen and Joan Mitchell from Yatts Farm. (Sydney Smith)

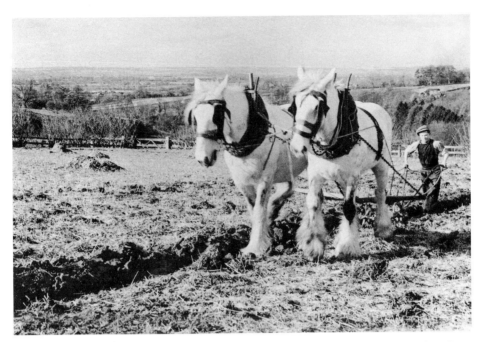

Edgar Dawson ploughing with two grey horses near Hutton-le-Hole, probably just before the Second World War. (Photographer unknown)

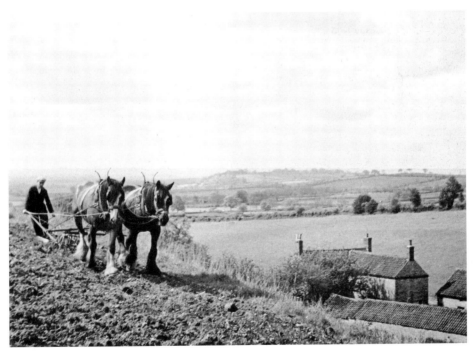

Mr Jack Stead of Wrelton ploughing with his horses Jet and Daisy at Pond Field, near Cass Hagg Farm, Cawthorn Lane, Wrelton. The horses were owned by Mr George Lumley of Croft Head Farm, Wrelton. (Sydney Smith)

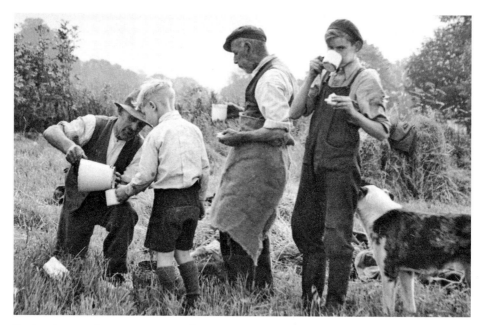

During the 1942 harvest at Low Beadlam, Aislaby. From left to right: William Hogarth (with jug), Lewis Stead (young boy), Jack Garbutt and Viv Charlton, with a dog named Rapp. (Sydney Smith)

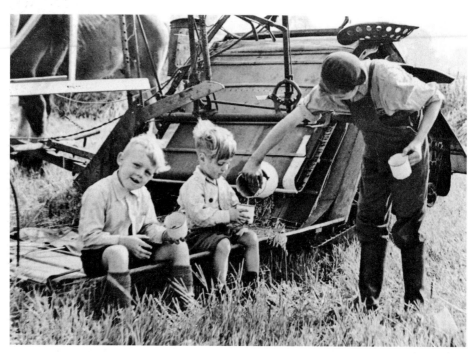

A 'lowance' break in the harvest field at Manor Farm, Aislaby, in 1942. (The word 'lowance' is an abbreviation of 'allowance'.) The two boys sitting on the binder are Lewis and Ron Stead, while Viv Charlton is pouring out the tea. (Sydney Smith)

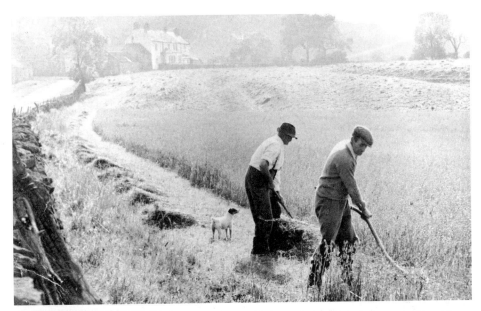

Tom Warriner of Bar Farm, Saltersgate, and his son, Edwin (in the flat cap), in 1942. They are 'opening up' a field by cutting the corn by hand before the reaper goes in. The Saltersgate Inn is in the background. Edwin Warriner lived at Nab End Farm, Saltersgate. (Photographer unknown)

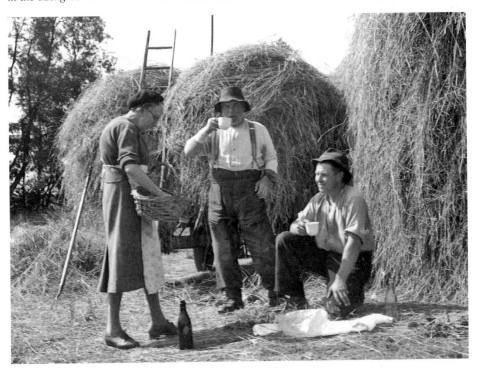

A welcome break in the work during hay time at Low Mill Farm, Pickering. Edie (?) serves refreshment to farmer Lawrence 'Lol' Best and his brother-in-law, Frank Steele (kneeling). Frank lived at Appleton-le-Street, but travelled to Pickering to help out 'Lol' and his brother Alf on the farm.(Sydney Smith)

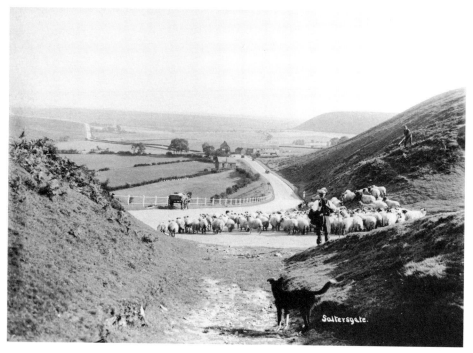

Tom Warriner (on hillside, from Bar Farm) and Dave Harrison (on road, from Low Horcum) herd sheep on Saltersgate Bank. The building on the left of the road in the middle distance was Saltersgate School. The school closed in 1932 and was demolished several years later; the stone was used in the construction of Mr S. Mackley's new farm. (Sydney Smith)

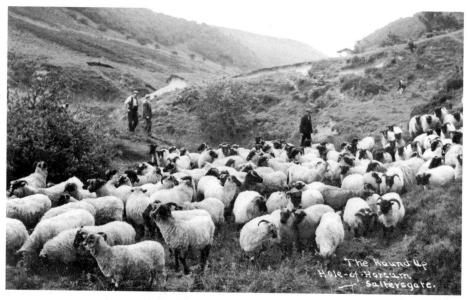

'The Round Up, Hole of Horcum': a group of farmers moving a flock of sheep near the main road at Saltersgate. The men from left to right are Bill Mackley, his son Sid, Stan Mackley and on the hill to the right is Ron Mackley. (Sydney Smith)

Farmers washing sheep at Glebe Farm, Saltersgate. The man standing behind with the flock is Stan Mackley, with George and Charlie Mackley in the water. (Photographer unknown)

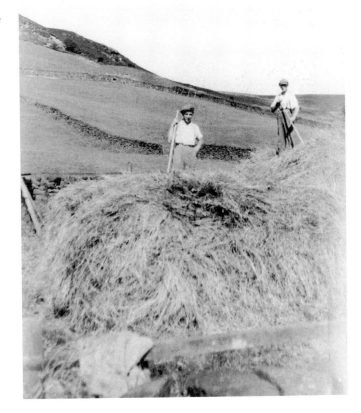

Haymaking at Hill House, Farndale. The workers are Herbert Wheldon and Harry Wilson. (Photographer unknown)

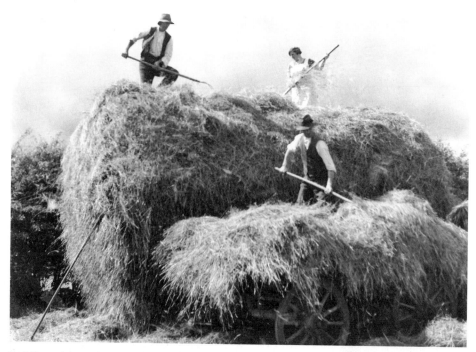

Building a haystack in fields at Rawcliffe Bank, Stape, near Newton-on-Rawcliffe. On top of the stack is Mr William Watson with his daughter Lillian Eddon, and Mr William Nichols is unloading the cart below. (Sydney Smith)

Low Kingthorpe Farm, near Pickering. The farm workers have gathered at the end of the harvest, with the traction engine and threshing set put away under sheets between the thatched stacks on the left of the picture (also known as Ricks or Peaks). (J. W. Malton)

Six

Sport and Leisure

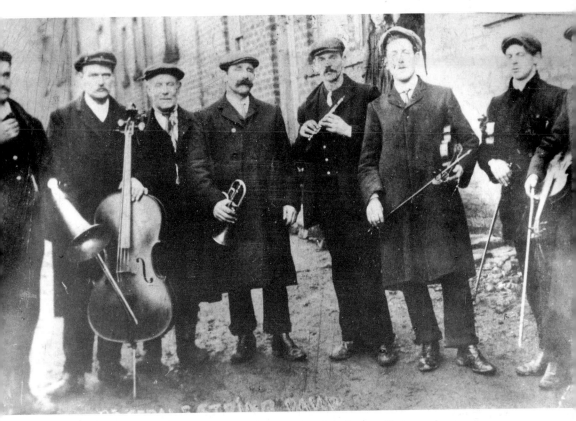

Rosedale String Band busking at Florence Terrace, Rosedale East, at Christmas between 1900 and 1904. They would be employed in the ironstone mines. From left to right: Tom Page, William Champion, Bob Hugill, Bob Jefferson, Bob Champion, Joe Hugill, Fred Champion, Captain Wesson (or Weston?). (Photographer unknown)

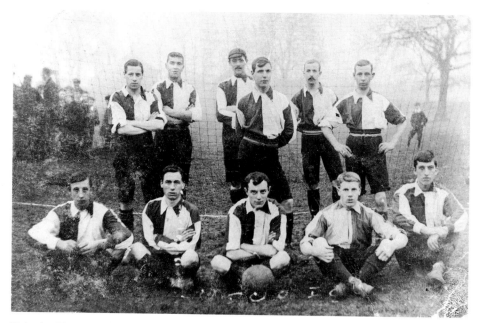

Pickering Town Football Club in 1908. They are seen at their ground at Ings Garth, Pickering. From left to right, back row: G. Ward, Alf Wilson, Albert Cass, W.E. Denney, H. Stevens, T. O'Connell. Front row: George Snowden, J. Hill, W. English, T. Coverdale, R. Blakelock. (Photographer unknown)

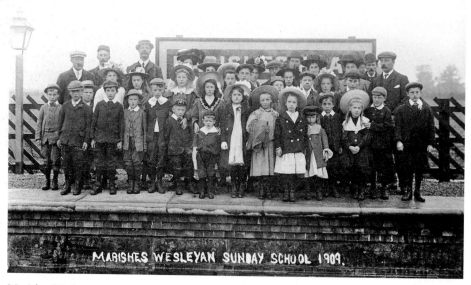

Marishes Wesleyan Sunday school, 1909. The children, all in their Sunday best, are waiting for a train at Marishes station. The occasion may be an annual free Sunday school excursion to Scarborough, which was an incentive to good attendance. The girl in the front row with the big hat and holding a coat is Linda Skaife, aged seven (later Mrs Linda Hoggarth of Thornton-le-Dale). (Sydney Smith)

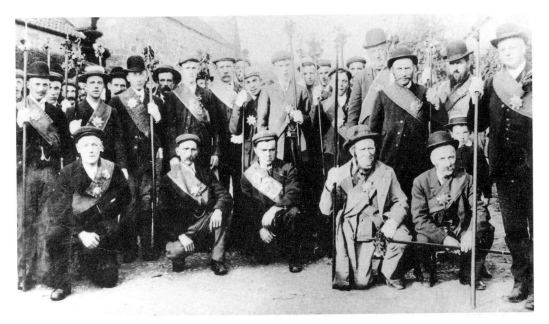

Members of the Shepherds' Retreat Club, Rosedale, pose with their shepherd's crooks and sashes in Haygate Lane, Rosedale, before 1910. (Tom Page)

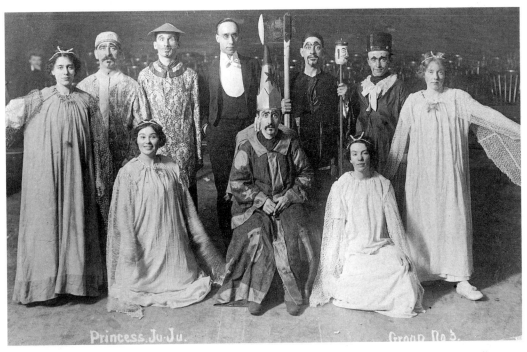

The cast of *Princess Ju-Ju*, as performed by Pickering Flashlight Group in the Temperance Hall, Pickering, in 1910. From left to right, back row: Sally Fletcher (later Mrs Wilson), Frank Redpath, Tom Taylor, Harry Pickering, Robert Fletcher, B. Lowe, Norah Smith. Front row: Lily Smith, -?-, Dorothy Hainsworth. (Sydney Smith)

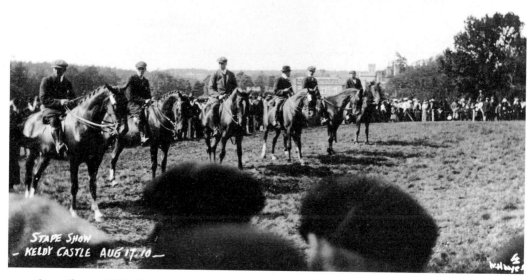

Stape Show at Keldy Castle, between Cropton and Stape, 17 August 1910. The horses are being judged in this view. The castle can be seen on the right in the background. (William Hayes)

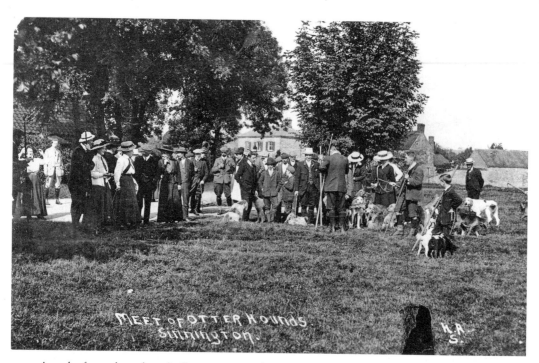

A pack of otter hounds and villagers meet on the village green in Sinnington in 1910. (H. Aldine of Sinnington)

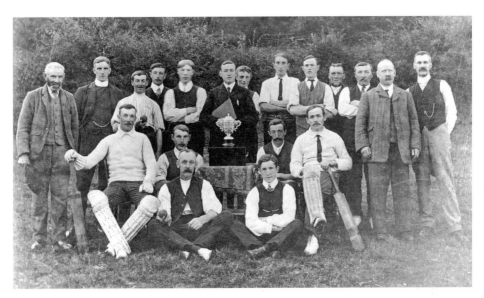

Farndale Cricket Club, with the silver cup they won in the 1912 season. From left to right, back row: Revd H. B. Greeves, J. W. Mortimer, E. Mortimer, T. Knaggs, J. R. Brown. Second row: J. L. Teasdale (umpire), B. Cole, T. Wheldon, J. Handley (scorer), T. Dale, W. Handley, W. Wheldon. Third row: T. J. Ward (captain), J. G. Wheldon (vice-captain), H. Thompson, F. Handley, J. Peacock (secretary). Front row: W. Holiday, J. Ward. (William Hayes)

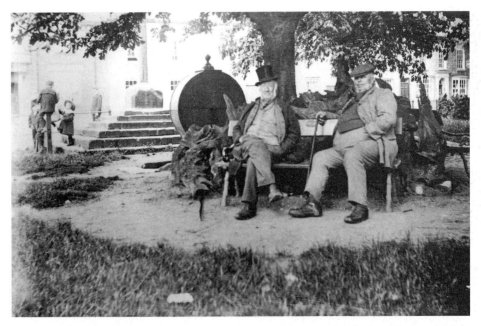

'Thornton-le-Dale natives'. Two unknown gentlemen are sitting in the shade of the trees in the centre of the village green at Thornton-le-Dale. The three children on the left are playing on the old wooden stocks, close to the village cross. The round object behind the man in the top hat is the village pump, made at the Fletcher brothers' foundry in Pickering. The animals would arrive by rail to Thornton-le-Dale station, before walking through the village and on to Pickering. (S. H. Smith of York)

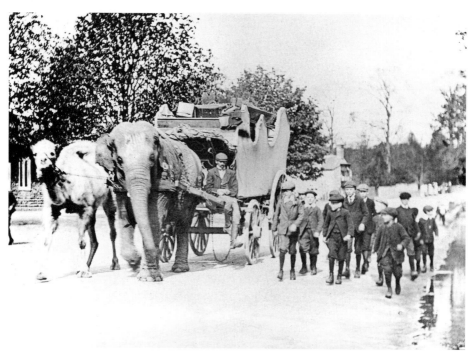

A camel and an elephant yoked up to pull a wagon in the early twentieth century. The wagon was part of Barnum and Bailey's circus which was moving through Thornton-le-Dale en route from Scarborough to Pickering. One wagon was being pulled by six white horses, but got stuck on Pickering Hill and had to be helped by the elephant. The animals would arrive by rail to Thornton-le-Dale station, before walking through the village and on to Pickering. (Photographer unknown)

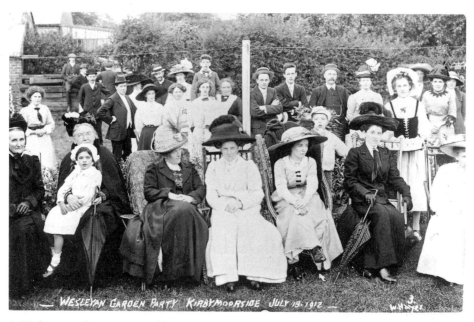

A Wesleyan garden party at Kirkbymoorside on 13 July 1912 (note the old spelling of the town's name – it now has an extra 'k'). (William Hayes)

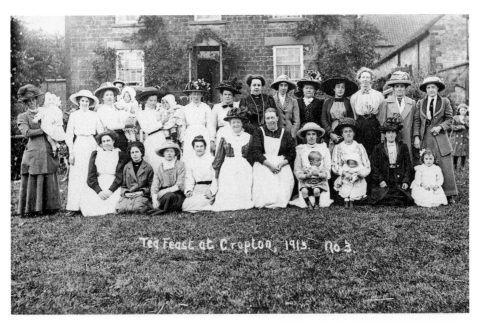

Tea Feast at Cropton, 1913. The Tea Feast was also known as the village fair and was usually held on the first Sunday in July at Whitethorn Farm. The farm was owned by Mr John Gill of Sutherland Lodge, who also gave Cropton its reading room. The ladies in the photograph produced the food for the feast. In the 1920s Fred Harland moved to Whitethorn Farm and the Wesleyan Sunday school children had their annual picnic there. (Sydney Smith)

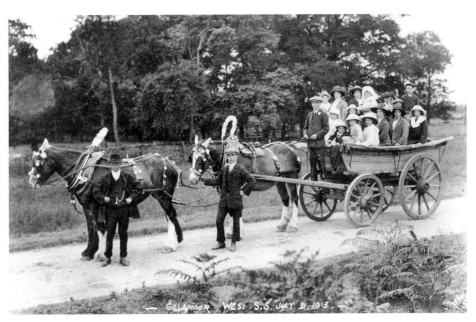

Gillamoor Wesleyan Sunday school outing, 31 July 1913. The horses have been decorated for the outing, including special woollen cones on their ears! (William Hayes)

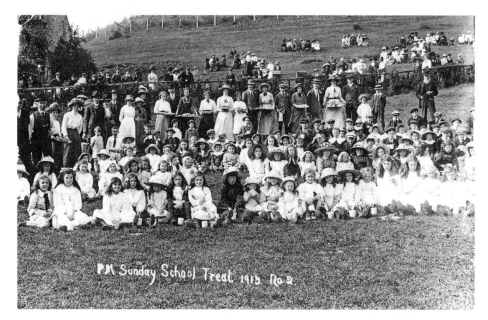

Pickering Primitive Methodist Sunday school treat at Park Gates in 1913. The children and helpers were transported by horse and wagons from the town and then enjoyed an open-air service, followed by sports and a picnic tea before returning home. (Sydney Smith)

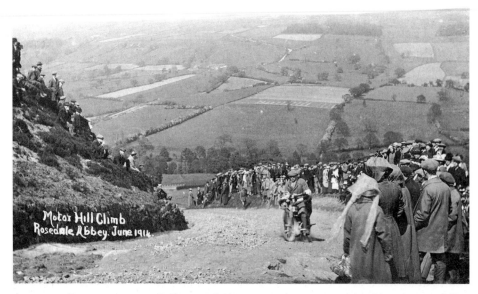

A motorcyclist attempts to reach the top of Chimney Bank near Rosedale Abbey during a hill-climb trial in June 1914. At this stage the road was still unmade. The notorious 1 in 3 slope of Chimney Bank was frequently used for hill-climbs by both motorcyclists and car drivers. This event was organised by Bradford Motor Club. (Sydney Smith)

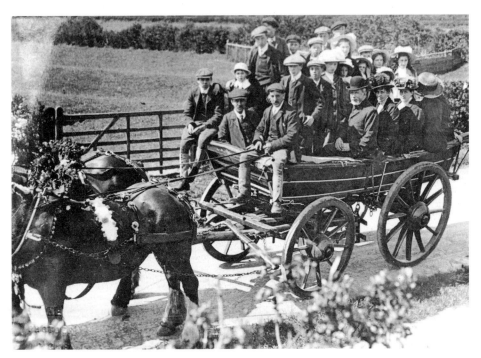

This group on an outing by wagon and horses is from Normanby Hill, near Normanby. The event and date are unknown, but the driver is known to be Albert Burton, who died in 1963 aged seventy-nine. (Sydney Smith)

Cropton Sunday school outing. The children pose on the platform of Pickering station before departing for Scarborough. The girl in the white dress in the middle of the back row is Ginny Hammond. (Photographer unknown)

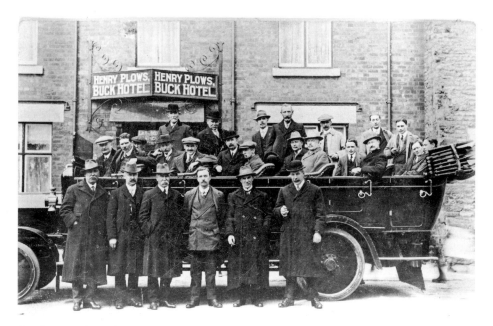

A pub outing from the Buck Hotel in Thornton-le-Dale. Henry Plows is the landlord. Note the solid tyres of the charabanc. (Photographer unknown)

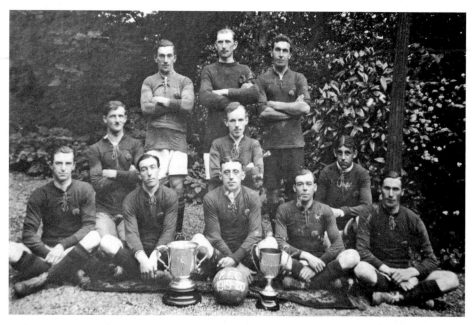

Pickering Town Football Club (also known as 'The Pikes'), 1919/20 season. This season was particularly successful for the team: they won the Ryedale League, the Scarborough and District Cup and the Scarborough Hospital Cup. From left to right, back row: Francis Bagshaw, Jack Lyon, Alf Wilson. Middle row: Roy Pickering, Ron Guffick, H. 'Yarb' Wilson. Front row: Jimmy Pickering, Robert 'Shad' Fletcher, Arthur 'Codge' Frank, Len Smith, Ernest Wiseman. (Photographer unknown)

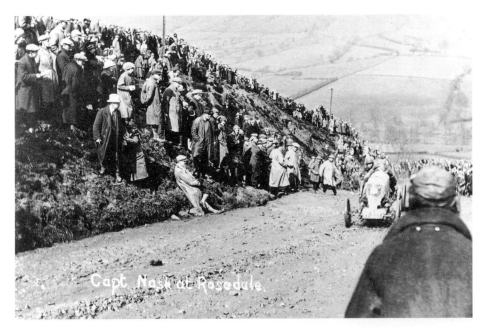

Captain Archie Frazer-Nash about to win the car event at the Chimney Bank hill-climb at Rosedale Abbey in 1921. He is driving a home-built car which he called *Kim* or *Kim II*. The hill-climb, organised by the Bradford Motorcycle and Light Car Club, was known as the Annual Classic Freak Hill-Climb. The Chimney Bank was first climbed in a motor vehicle in 1911, by Frank Philipp. (Sydney Smith)

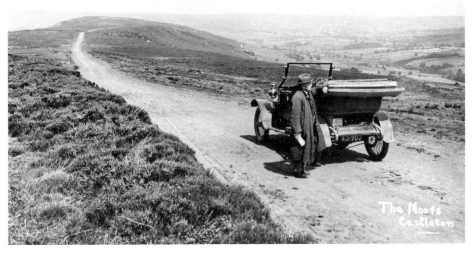

Pickering dentist Harry Place takes a rest from driving on the moors above Castleton. (Sydney Smith)

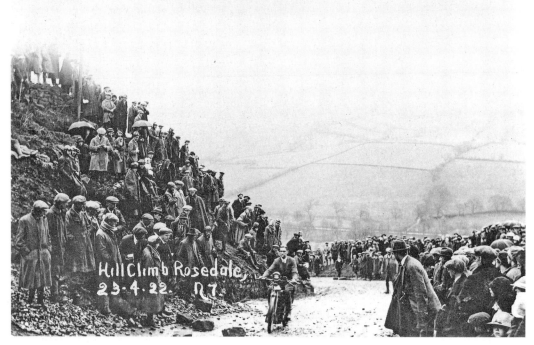

A motorcycle attempts the 'freak' hill-climb up Chimney Bank, Rosedale Abbey, on 23 April 1922. (Sydney Smith)

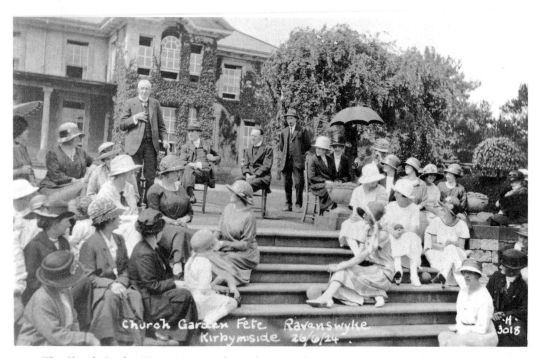

The Church Garden Fête at Ravenswyke, Kirbymoorside, on 26 June 1924. (William Hayes)

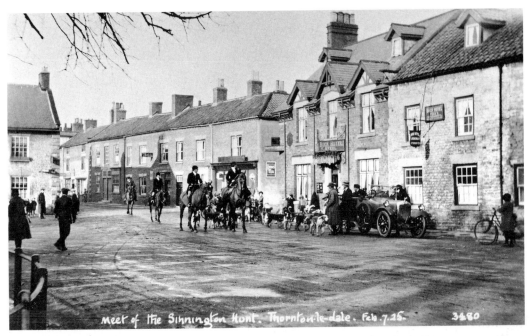

A meeting of the Sinnington Hunt outside the Buck Hotel, Thornton-le-Dale, in February 1925. The landlord of the Buck was T. Steel and the corner shop at the bottom of Whitbygate has Parkinson's on its signboard. Next door is G. Barnes' fruit shop. (William Hayes)

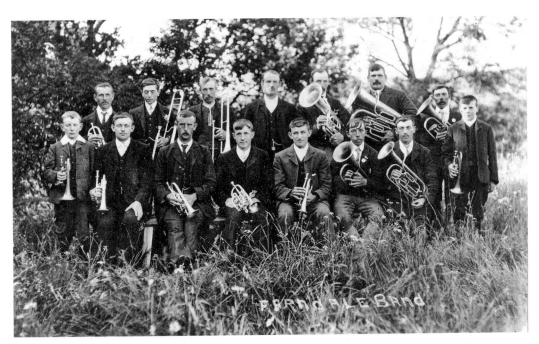

Farndale Band at an unknown date – probably 1920s. Those present include Jonathan Champion (bandmaster), Eric Middleton, Herbert Atkinson, Walter Thompson, Jack Lumsden (a thatcher) and Harry Hugill (a joiner). (Sydney Smith)

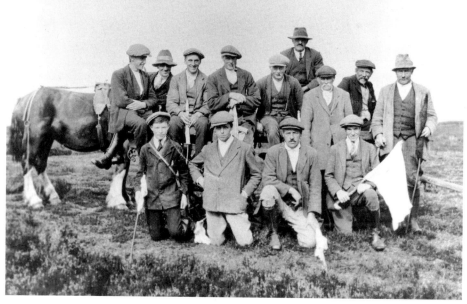

The beaters assembled for a grouse shoot on the moors near the Pickering to Whitby road at Saltersgate. The date is unknown. At the back: Tom Warriner (his horse Julie is on the left). From left to right, middle row: -?-, George Watson, Stan Mackley, -?-, Dave Harrison, Charlie Harrison, -?-, Edwin Warriner. Front row: -?-, Jack Mackley, Lewis Pennock, -?-. (Photographer unknown)

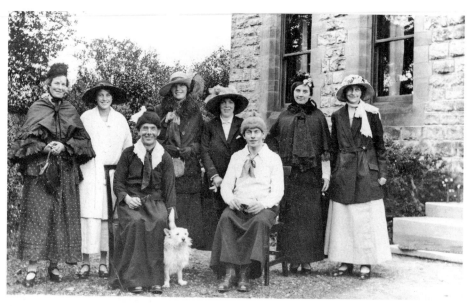

A concert party at Newton-on-Rawcliffe in 1929. From left to right, back row: Mrs George Pearson (*née* Estill) Mrs O. Humble (*née* Lucy Boyes), Mrs E. Boyes (*née* Nellie Ranson), Mrs Ida Wilson, Mrs Alianson (*née* Estill), Mrs Botterill (*née* Lambard). Front row: Revd Gill (with dog) Frank Hardcastle. (Sydney Smith)

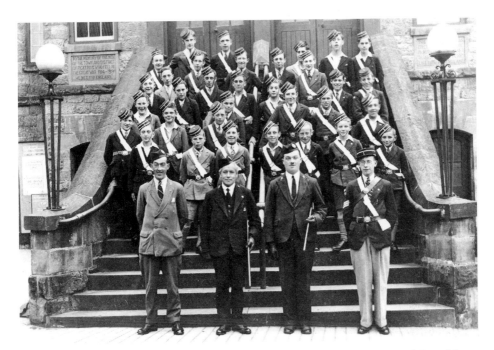

Pickering Boys' Brigade on the steps of Pickering War Memorial Hall in 1932. From left to right, back row: all unknown. Fifth row: John Greenheld, -?-, Tom Wentworth, Robert Strickland, Arthur Thompson. Fourth row (staggered): George Magson, -?-, -?-, Frank Wilson, William Hesp, Arthur Sayers, -?-, Guy Wilson, -?-. Third row: -?-, Rowland Magson, -?-, Wilf Pickering, John Hill (?). Second row: Frank Humble, Bernard 'Bant' Wiley, J. Hill, -?-, -?-, John Ewbank, -?-, -?-. Front row: Lt Harry Gott, Capt. Harold Markham, Lt Bill Shimmin, Sgt George Bower. (Sydney Smith)

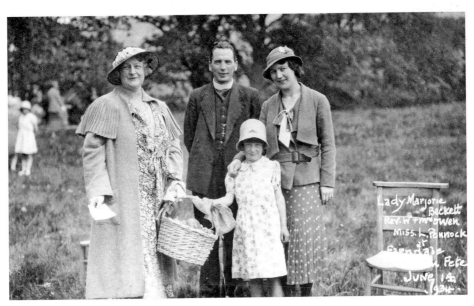

The official opener, Lady Beckett, arrives at Farndale Garden Fête, 14 June 1934. With her are the Revd W. Owen and his wife, and in front is Miss L. Pennock. (William Hayes)

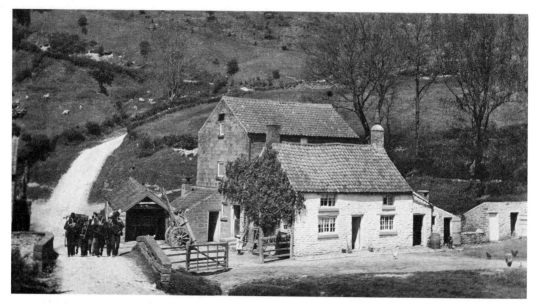

Stape Band passing Levisham Mill after playing in Levisham village. They are marching up to Lockton. (J. W. Malton)

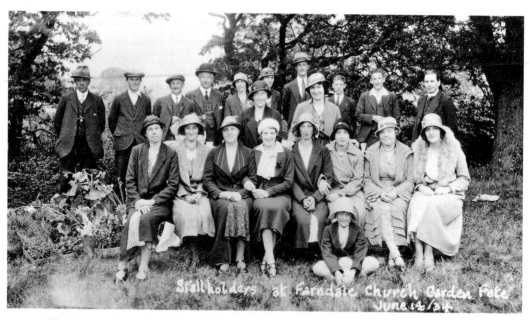

Stallholders at Farndale Church Garden Fête, 14 June 1934. From left to right, back row: Fred Dunn, Albert Ward, Mr Mortrum, Watson Mortimer (in bowler hat), his wife Alice Mortimer, -?-, Mr Horner (the local policeman, in the trilby), -?-, Stanley Mortimer, Revd Owen. Middle row: Mrs Ward, Mrs Owen (the vicar's wife). Front row: Mrs Fred Dunn, Annie Featherstone, Mrs Brown (the schoolmaster's wife), Olive Kaye, Mary Maw, Nancy Shippy, Mrs Charles Mortimer, Mrs Horner (the policeman's wife). The young girl sitting in front is Lucy Pennock. (William Hayes)

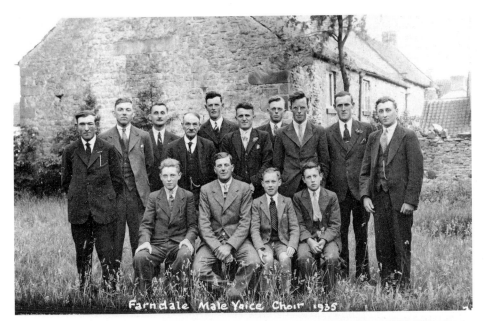

Farndale Male Voice Choir, 1935. From left to right, back row: Ernest Carter, John Wass, Fred Wass. Middle row: Joseph Teasdale, Herbert Breckon, Jonathan Champion, Clark Thompson, Harry Wass, Herbert Dobson, Herbert Carter. Front row: George Breckon, William Dunn, Eric Dobson, Harold Dobson. (William Hayes)

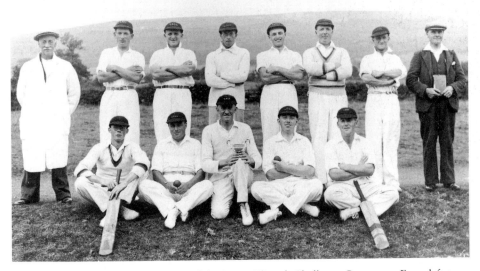

Low Farndale Cricket Club, winners of the Henry Flintoft Challenge Cup, 1937. From left to right, back row: A. Knight (umpire), Noel Frank, Clark Thompson, Ernest Ventress, Fred Potter, Walter Thompson, John Wilson, William Tinsley (scorer). Front row: Fred Wass, Jack Atkinson, J. Ward (captain), Herbert Breckon, Fred Dawson. (Photographer unknown)

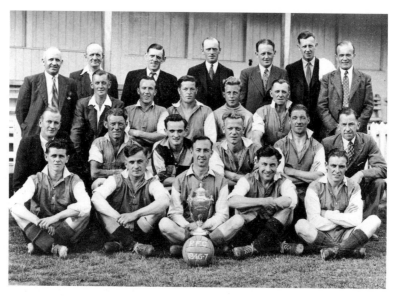

Members of Pickering Football Club, winners of the Malton Senior Cup in the 1946/47 season, line up with club officials in front of the old pavilion on Recreation Road. Back row: John Smith, John Bower, Sid Dale, Bill Martin, Tom Ewbank, Malcolm Jemmison (trainer), Harold Wardell. Third row: Arthur Pickering, Harry Ellerby, Arthur Malton, Ken Drinkle, Percy Myers. Second row: Bill Thompson, Eric Nicholson, John Lack, Tommy Elias, Barney Lewis, Gilbert Johnson. Front row: Joe Morrison, Don Rudd, Jack Campbell, Albert Errington, Sandy McNeil. (L. Shaw)

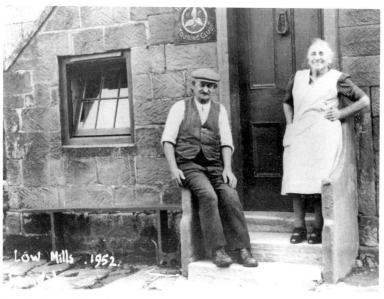

Cobbler Ben Cole and his wife lived in the Square at Low Mill, Farndale. Mrs Cole served tea to cyclists and they displayed the Cyclists' Touring Club sign near their door. This picture dates from 1952. (Raymond Hayes)

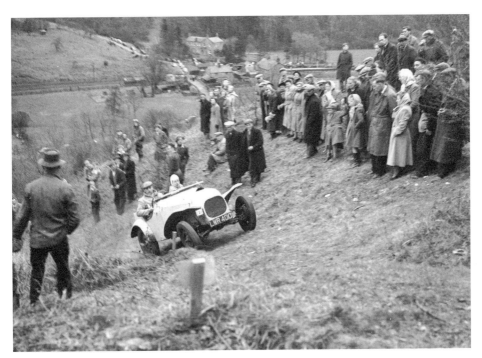

Norman Coates on the way to winning the Wilson Trophy at the Newton-on-Rawcliffe hill-climb, near Levisham station, in 1953. He is driving a car that he designed and built himself, called the Coates Special. It is based on a modified Ford Ten with side-valve engine. During the early 1950s Norman won over 100 trophies in this car. (Sydney Smith)

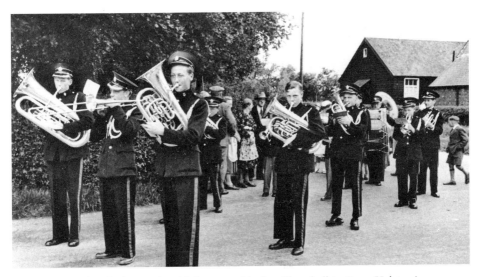

Pickering town band, about to march from outside the village hall in Great Habton in 1952 or 1953. The village hall and part of the church can be seen to the right. The bandsmen are thought to be, from left to right, front of march to back: Jimmy Bullock, Cyril Richardson, Alan Gibson, Lewis Rex, Tony Pape (hatless), Eddie Thompson, Cyril Smurthwaite, Bobby Frank (with drum) and Ronnie Stead. (Photographer unknown)

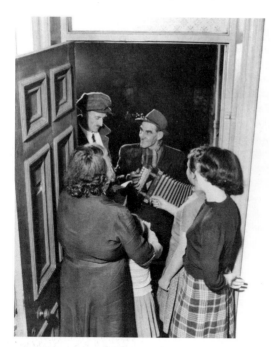

Pickering Waits visit Dennis House in Eastgate (now the Crossways Hotel) in 1952. The Waits were a local tradition that later died out in the early 1960s. Two local men would visit households at night in order to wish them a merry Christmas and good luck in the new year. One of the Waits would play his piano-accordion. Early in the new year they would revisit the houses they went to before in order to collect some remuneration from the householders. On the doorstep are Mr Maurice Dale and Mr Ernest Richardson (with mistletoe in his hat, and holding the accordion); inside are Mrs Stead, an unknown girl, Mearl Grimes and Audrey Grimes. (Photographer unknown)

An outing from the Sun Inn, Pickering, to Bridlington in 1955 or 1956. This view is at the war memorial in Sledmere. Back row: Bill Hare, Wilf Hare, Tom Leng, Ike Lack, (in front of him) Peter Anderson, Ernest Marshall, Mr Gray. Fourth row: Harwood Leng, -?-, -?-, Charlie Robinson (in trilby), Tom Wentworth, Jim Campbell, George McCauley. Third row: Bob Wardle, Bill Dixon, George Lyon, Albert 'Sham' Middleton, Jack Watson, Harry Knowles, Jack Wentworth, Frank Maymen, Henry Hey, Bill Dymock. Second row: Herbert Knott, Ted Ayers, Harry Watson, George Wood, Mr Robson, Bernard Harland, Dick Baldry, Walter Lack, John Weighell. Front row: John Ewbank, John Morley (drivers in white coats), Fred Benson, Ridler Boyes, Brian Wardell, Derek Cousins, Joe Sheridan, Sydney Boyd (Landlord), Frank Page, Arthur Cousins, Jock Campbell, Fred Moment, Alf Best (driver). (T. Hollingsworth)

Seven

Events

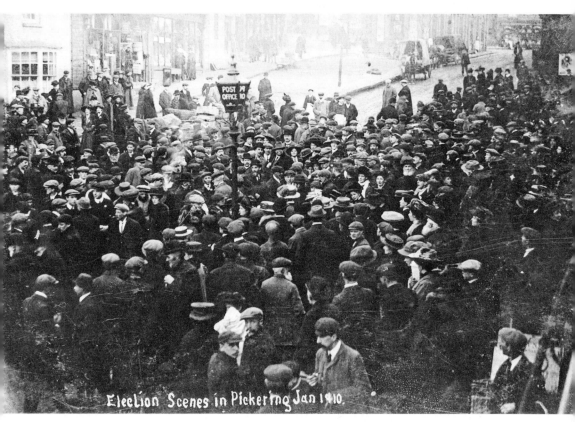

Election Scenes in Pickering Jan 1910.

A crowd gathers as election fever grips the voters of Pickering in January 1910. This is the Market Place, with the White Swan hotel on the left and a gas light on the right, marking the position of the post office. This scene is probably of electors awaiting the announcement of the election results. (Sydney Smith)

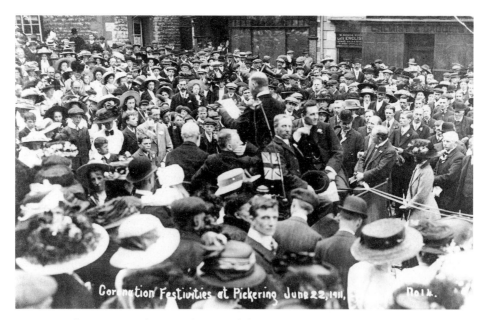

Coronation festivities in Pickering in honour of the new king George V, on 22 June 1911. The man in the centre, speaking from a horse-drawn trap, is thought to be Major Mitchelson from the High Hall. The building on the right is Norman Wood's chemist's shop. He took over from Ann English. (Sydney Smith)

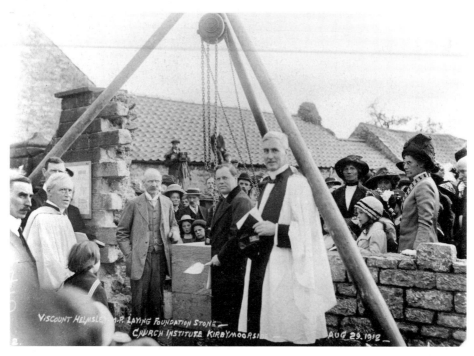

Viscount Helmsley MP lays the foundation stone for the Church Institute, Kirkbymoorside, 29 August 1912. (Photographer unknown)

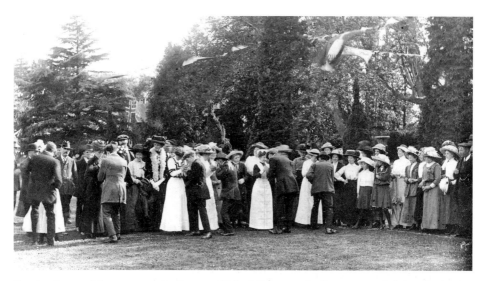

Empire Day, 24 May 1913, at the Rectory, Kirby Misperton. Ladies are seen lighting the men's cigarettes, ready to take part in the cigarette race. What is involved is not recorded, but it looks as if the men took part in a sprint while smoking. (Sydney Smith)

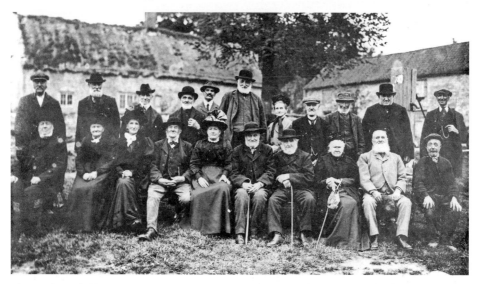

'The Wrelton Challenge'. Following publicity in the local press, a challenge was issued by Wrelton on 16 May 1914 to better their record of having thirty residents over seventy years of age among a village population of 150. The challenge was never accepted, but Wrelton's septuagenarians lined up for a publicity shot on the village green. From left to right, back row: J. W. Dinsley (73), William Stead (74), William Hardwick (80), William J. Ward (81), Thomas Turnbull (organiser), F. Thomas Atkinson (78), Mrs Atkinson (74), J. Watson (73), J. Stead (75), Robert Ward (84), Robert Page (78). Front row: W. Champion (84), Mrs Chapman (75), Mrs Berriman (75), W. Turnbull (76), Mrs Turnbull (73), J. Turnbull (82), John Page (91), Mrs Randall (85), Mr Randall (84), Matty Law (71). Others not included here were: Mr Otley (76), Mr R. Brisby (78), Mrs Brisby (72), Mrs Pickering (72), Miss Middleton (71), Mrs Campion (87), Mrs Warwick (81), Mr and Mrs Hardwick (70 and 71), Mrs Dinsley (70), Mrs Bowes (93). They were all members of the Primitive Methodist Church, and some eligible members were unable to attend on the day. (Photographer unknown)

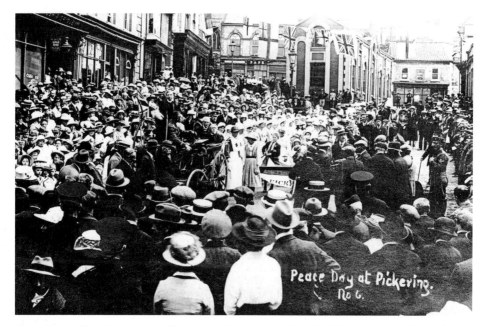

Peace Day at Pickering in 1919. The procession down the Market Place was to celebrate the formal end of hostilities after the First World War, the signing of the Treaty of Versailles. The central group includes the Pickering VAD (Voluntary Aid Detachment) nurses from One Oak, Hallgarth. (Sydney Smith)

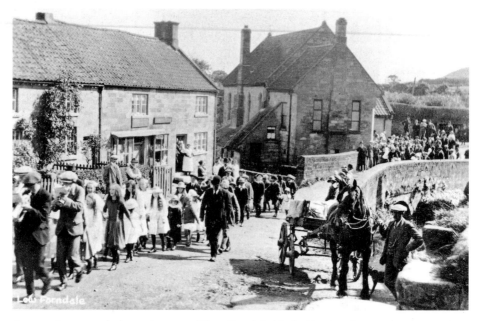

A procession to mark the anniversary of Low Farndale Methodist chapel on 27 August 1926. It was led by the band and began in the chapel at Low Mill. The man on the right holding the horse is Joe Carter, who owned High Shop in High Farndale. The man at the front of the parade is James Wass and the lady in the shop doorway is Mrs Annie Middleton. (William Hayes)

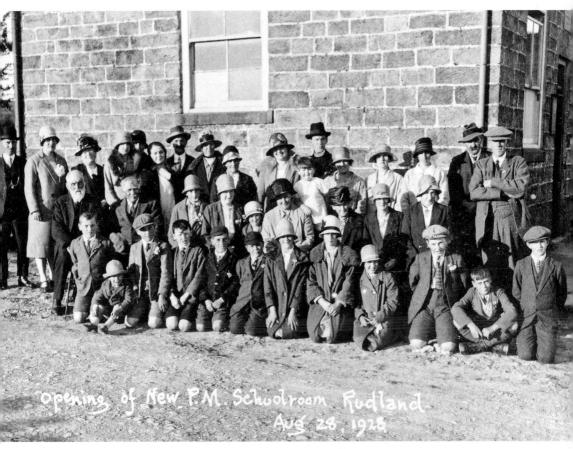

Opening of the new Primitive Methodist schoolroom at Rudland, 28 August 1928. Those present include: Mr and Mrs C. Green, Mr and Mrs T. Fletcher, Miss Rogers, Mr and Mrs J. Fletcher, Mrs C. Wardley, Miss Wilson, Miss R. Richardson, Miss R. Teasdale, Mr and Mrs Fielden, Mr J. Waler, Miss L. Waler, George Willoughby, John Richardson, Tom Fletcher, Jackson Teasdale, Miss L. Fletcher, Wilf Fielden, Miss J. Richardson, Mr Waler. (William Hayes)

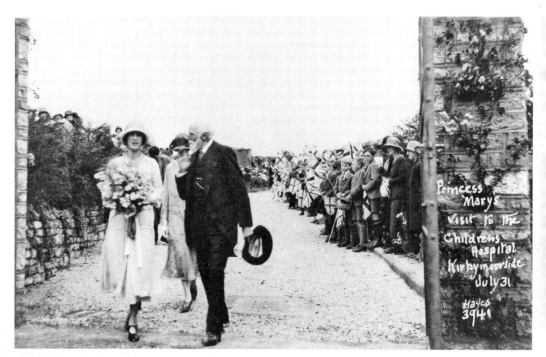

In July 1931, the Princess Royal, Princess Mary, visited the children's hospital at Kirkbymoorside. (William Hayes)

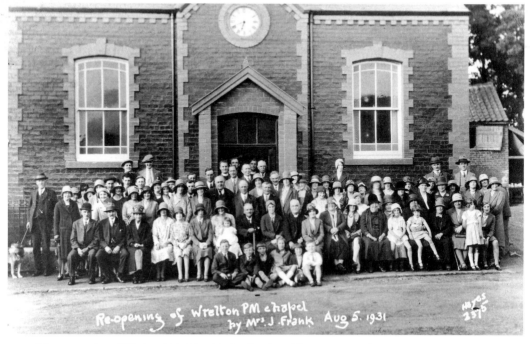

The re-opening of Wrelton Primitive Methodist chapel by Mrs J. Frank on 5 August 1931. It is thought that William Wilson from Cawthorn and Tom Turnbull are among the group. (William Hayes)

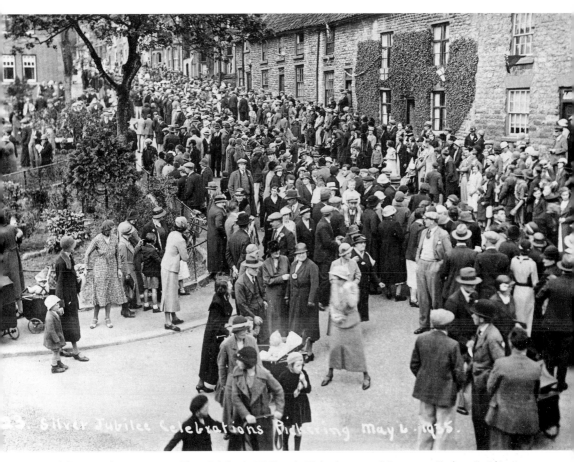

Celebrations for George V's Silver Jubilee in Hallgarth, Pickering, on 6 May 1935. (Sydney Smith)

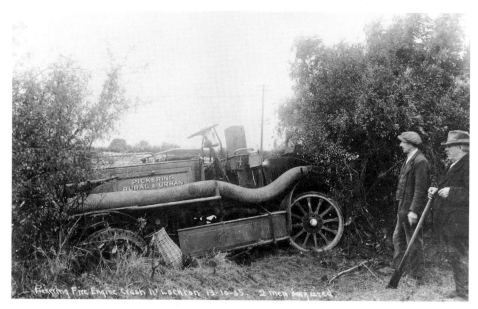

On 13 October 1935 the Pickering fire engine crashed near Lockton, injuring two men. Here, Tom Robinson and George Welburn from Lockton survey the wreckage near the first lane into Lockton on the Pickering to Whitby road. One of the injured firemen was Joe Taylor of Pickering. The fire engine had been presented to Pickering Urban and Rural District Councils in 1926 by Alderman Twentyman from Kirby Misperton. (Sydney Smith)

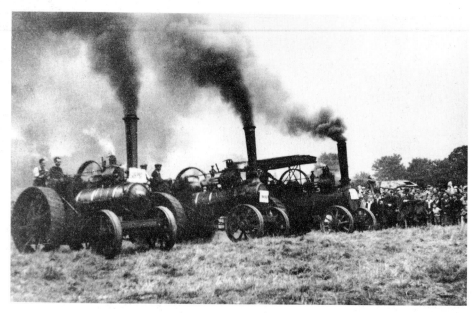

The first traction engine derby in the north of England was organised by Pickering Sports Committee in May 1953 at Mill Lane, Pickering. Over 5,000 spectators attended and it was the first event in Pickering to be televised. The rally was won by *Old Glory*, driven by Ernest Mortimer and owned by builder Les Lazenby, both from Pickering. (Sydney Smith)

Eight
Wartime

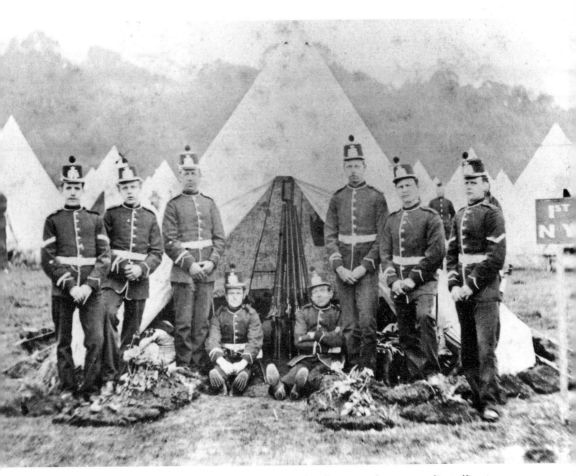

Castle Howard Camp, 12 June 1880. Major C. Worsley, Bart, was the commanding officer. The man second from left (standing) is Alonzo Longbotham of Malton, who was born in 1856. He joined the Army Medical Corps and died at an unkown date of fever in Mauritius. (Photographer unknown)

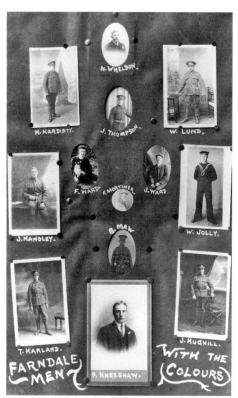

Two montages of some Farndale men who fought in the First World War. (Photographers unknown)

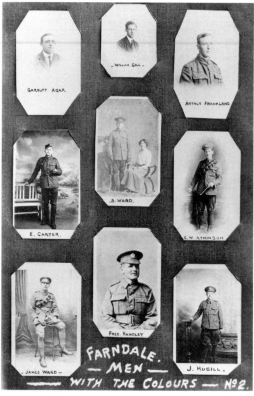

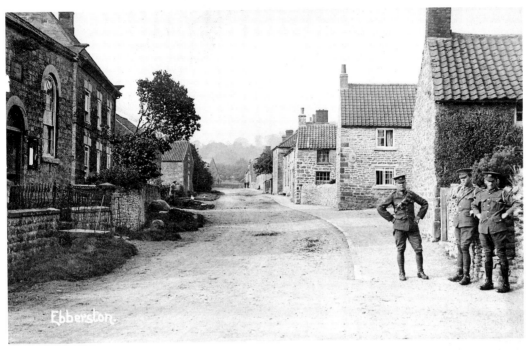

Soldiers standing in the main street at Ebberston in 1914. (Sydney Smith)

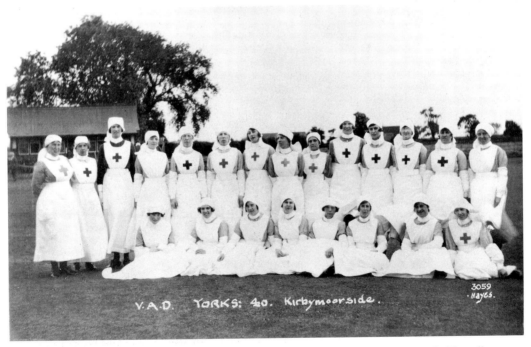

Nurses of 40th Yorkshire VAD (Voluntary Aid Detachment) pose at Kirkbymoorside. The tall lady third from the left on the back row was the Commandant, Mrs Shaw, who was married in Ireland in 1919 and moved to North Yorkshire shortly afterwards. (William Hayes)

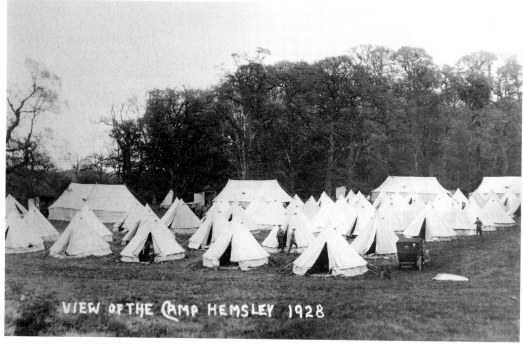

An Army camp held at Duncombe Park, Helmsley, in 1928. (Photographer unknown)

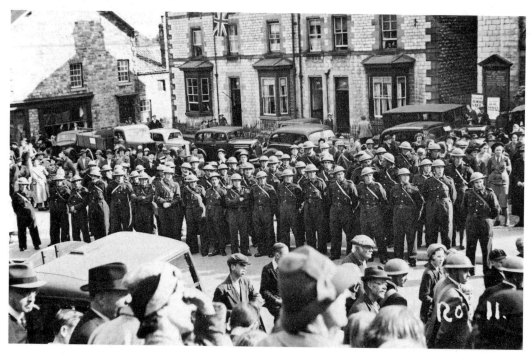

People are gathering on Potter Hill ready for an inspection. It is thought the date could be
14 September 1940, when Lord Bolton, Lord Lieutenant, inspected local Civil Defence Services.
(Sydney Smith)

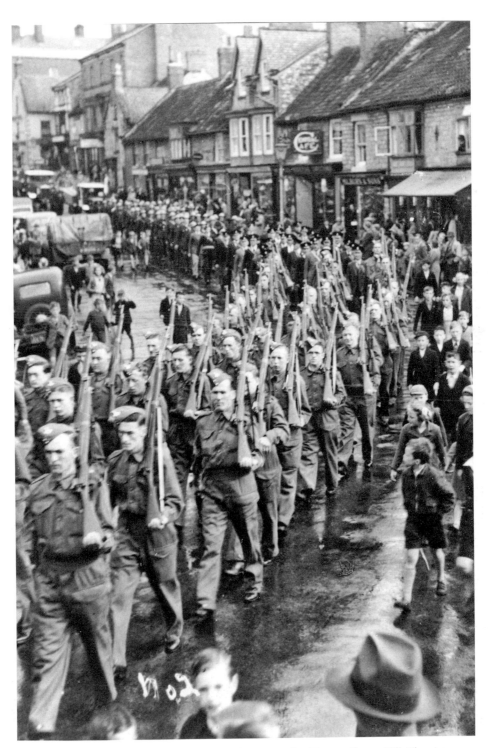

The Pickering Home Guard parades down Pickering Market Place to Potter Hill. The picture was thought to have been taken either for an inspection held on 14 September 1940, or at the end of the war.

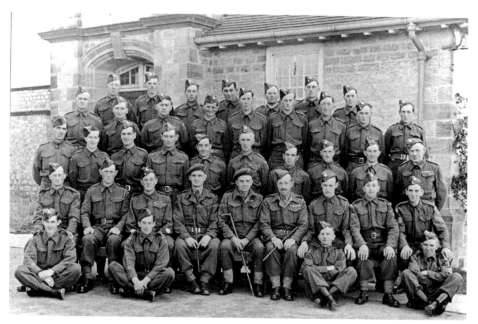

The 7th North Riding Battalion Home Guard, No.5 Platoon, 'D' Company, seen at Lady Lumley's School, Middleton Road, Pickering, in October 1944. From left to right, back row: Fred Hardy, Stanley Smithers, Fred Ward, Eric Welburn, William Stead, Walter Barnes, Jim Stothard. Fourth row: -?-, -?-, Bob Stork, -?-, John Stothard, Bob Vasey, Ted Smith, Walter Hornby, Tom Brewster. Third row: -?-, -?-, Harold Middleton, -?-, -?-, -?-, George Smith, Fred Martin, Tom Smith, Arthur Gibbs. Second row: Stanley Harrison, Ralph Stothard, Herbert Horsfall, Harold Bielby, -?-, James Whitehead (officer), George Ploughman, John Dymock, Edwin Cooper. Front row: John Brisby, Henry Peirson, Neville Fenwick, Albert Fenwick. (Massers of Malton)

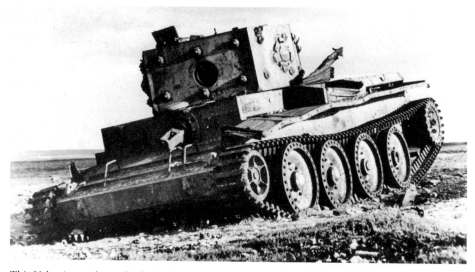

This Valentine tank, a relic from the Second World War, was abandoned and lost in a bog during training exercises on top of Hazel Gill, Saltersgate, in the early 1940s. The Valentine was the standard infantry tank of the 1930s. (Sydney Smith)

Nine
Transport

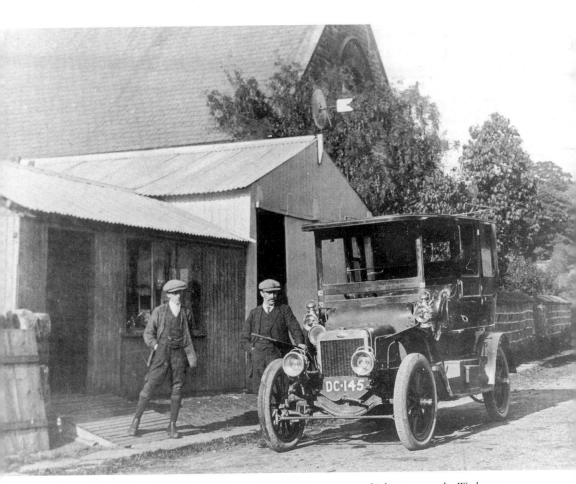

Brothers Herbert and William Smith outside their Aero garage, which was near the Wesleyan chapel In Haygate Lane, Rosedale Abbey. The car is an Edwardian taxi, of which more overleaf. The garage has since been demolished. (Sydney Smith)

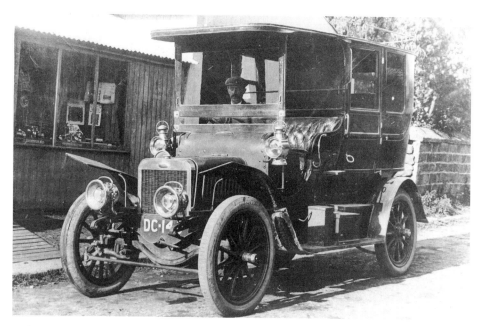

William Smith at the wheel of his taxi outside the Aero garage in Rosedale Abbey, some time in the second decade of the twentieth century. The vehicle is a two-cylinder Albion with low-tension magneto ignition, acetylene headlamps and oil side and tail lamps, and is chain driven. The Smith brothers bought it second-hand in 1911 and ran it for hire until 1921. (Sydney Smith)

The Carr family, Matthew (schoolmaster at Middleton School), Norman, Maria and Doris, stand with their bicycles outside the family home, School House, in Aislaby in 1912. (Sydney Smith)

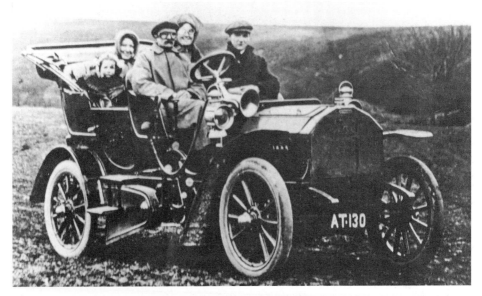

Mr Frank Skaife in his Studebaker car near the Saltersgate Inn, *c.* 1913. The little girl on the back seat was later Mrs Gordon Deal. (J. W. Malton)

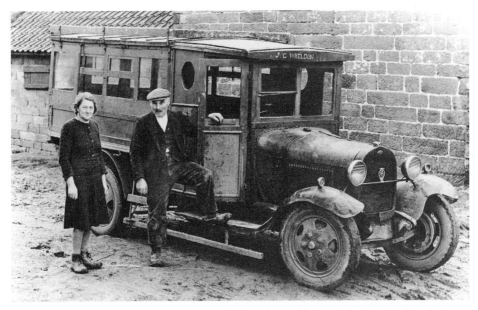

Mr John Wheldon and his wife, Caroline, with their Ford lorry/bus at their farm, Court Hill in Farndale, in the late twenties. The old grey lorry used to make scores of journeys out of the dale laden with market-goers with baskets of produce bound for Kirkbymoorside market; the roof was often piled high with baskets and boxes. This was one of the first vehicles in Farndale. As well as market trips undertaken regardless of the weather every Wednesday to Kirkbymoorside, it was also used for wedding and funeral parties. Caroline was John's constant companion on these trips and would act as conductor. In 1929 the lorry was sold to a garage in Gillamoor. (Photographer unknown)

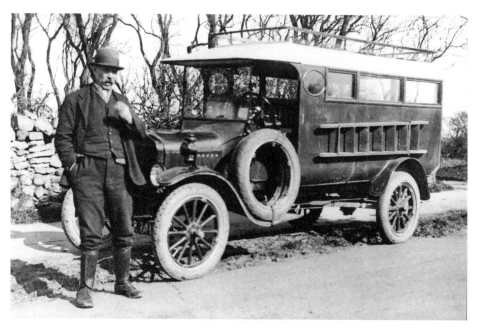

It is thought that this bus was operated in Rosedale, by Tom Chipchase, who was always prepared to turn his hand to anything in order to make a living. As well as being a bus operator, he also at various times had a fish and chip shop, and later sold ice cream, before along with his family, he later emigrated to Canada. The ladder on the side of the bus was used to load luggage onto the roof of the vehicle. (Sydney Smith)

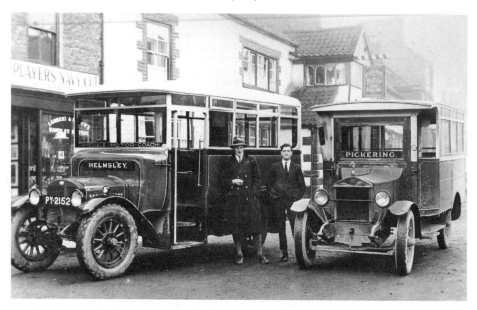

Two buses wait outside the Black Swan Inn, Kirkbymoorside, ready to depart for Pickering and Helmsley. The driver on the left is thought to be Mr Featherstone of Kirkbymoorside and the other is Bill Johnson of Middleton Road, Pickering. The left-hand bus is a 1922 Atlas and the right-hand a 1925 GMC. Both were owned by Mr Arthur Robinson, who operated Ryedale Coaches from 1922 until the company closed in 1968. (Photographer unknown)

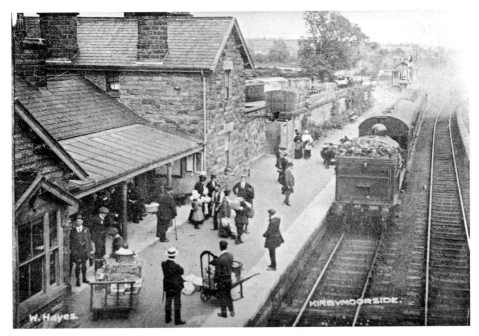

Passengers and railway staff contribute to this busy scene at Kirkbymoorside station. After the closure of the line, the land was sold off. The station was demolished in the spring of 2010 to make way for housing development. (William Hayes)

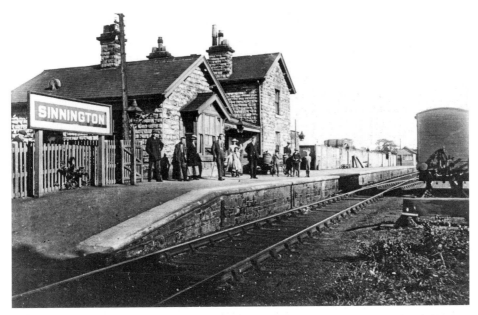

Sinnington railway station at an unknown date. The railway has since been closed and the station converted into cottages. (Photographer unknown)

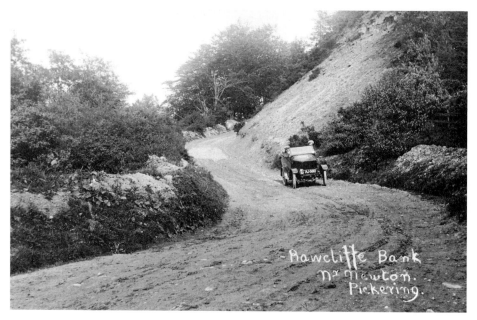

A car descends Rawcliffe Bank between Newton-on-Rawcliffe and Stape. The date is unknown, but given the age of the car and the primitive state of the road, it is probably during the 1920s. (Sydney Smith)

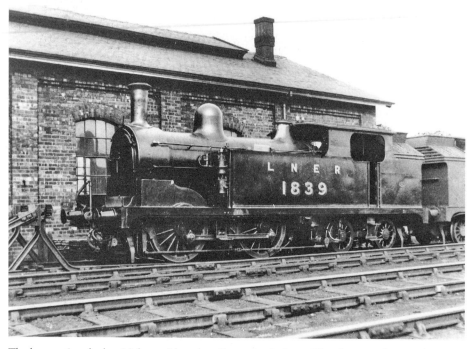

The locomotive shed at Malton with a class G5 engine in front. The photograph must date from before 1948, as the railway companies were nationalised in that year and amalgamated into British Railways. (Photographer unknown)

Ten
Weather

Ploughing Snow at Rosedale, 1900

Ploughing snow at Rosedale in 1900. The Rosedale Ironstone Mining Company had to keep the railway line clear of snow in order to move the iron ore over the highest part of the North York Moors. Three engines were used to push the snow plough, but the front engine would often be lifted off the track, it then had to be dug out by hand. (T. Page)

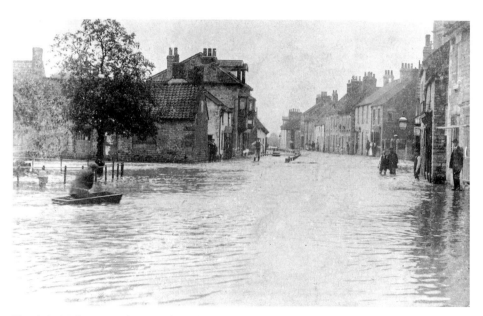

Floods in Maltongate, Thornton-le-Dale, in 1910. The man on the left is using a scalding tub (for removing hair from the carcasses of slaughtered pigs) as a makeshift boat. The village stream should be on the left and the village green, with stand tap for drinking water, is near the trees. (Photographer unknown)

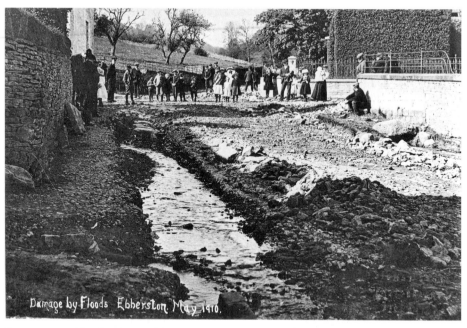

Damage by Floods Ebberston. May 1910.

Damage caused by floods at Ebberston in May 1910. The villagers have gathered to survey the damage to the unsurfaced road caused by the small stream that flows through the village bursting its banks. (Sydney Smith)

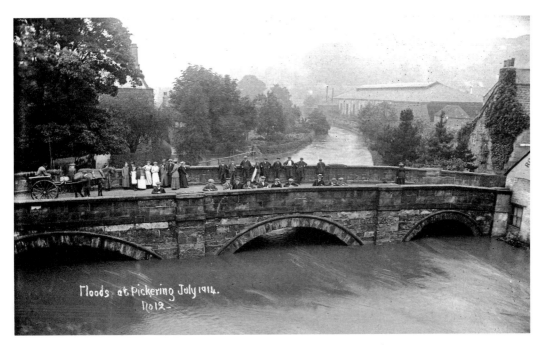

People and a horse and cart gather on the old bridge at Pickering in July 1914, to survey the rising flood water. The doctor's residence, Beech Grove, is on the left; it is now Beck Isle Museum. The railway station is on the right. (Sydney Smith)

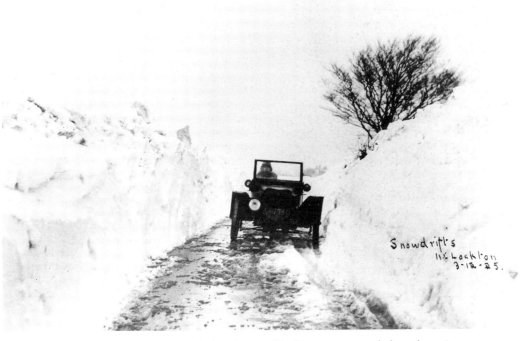

Snow has been cut out by men with shovels to enable this car to proceed along the main Pickering to Whitby road, near Lockton, on 3 December 1925. (Sydney Smith)

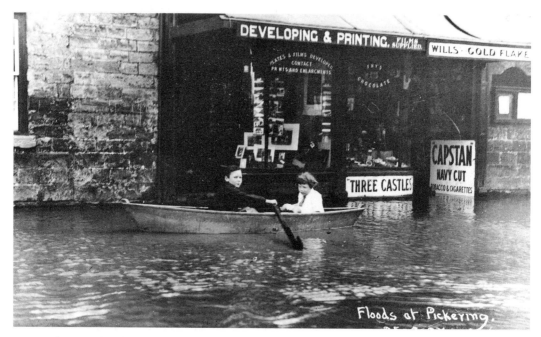

Sydney Smith's children, Edmund and Barbara, are rowing in their home-made boat in front of the family shop at the bottom of Pickering Market Place, 25 August 1927. The shop was later demolished, and the Yorkshire Trading Store now occupies the site.(Sydney Smith)

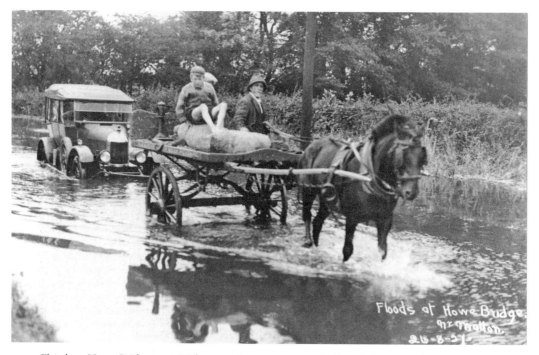

Floods at Howe Bridge, near Malton, 26 August 1927. Mr Pickering, from Kirbymisperton, drives his horse and two-wheeled flat cart in order to give a stranded motorist a tow through the flood water. (Sydney Smith)

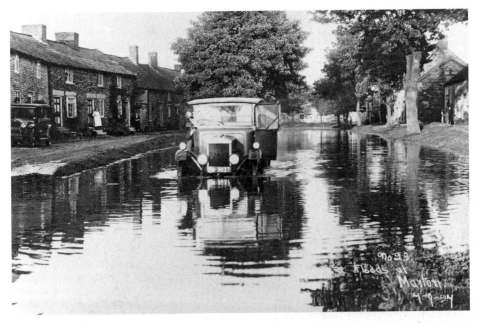

Flood water flows down the road in Marton village as a car makes ripples, 7 September 1927. It is thought that the driver of the car was Eddie Smith, the photographer's son. The lady standing on the left is Mrs May Elizabeth Taylor-Frank (*née* Lack); she died in April 1953 aged sixty-five. (Sydney Smith)

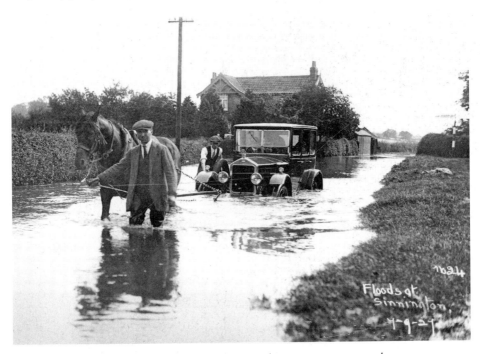

Floods at Sinnington, 7 September 1927. Once again horse power comes to the rescue as two men and their horse tow a car through the water at the entrance to the village. The village still suffers from flooding. (Sydney Smith)

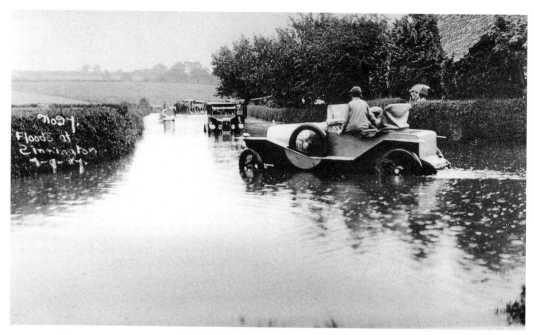

Another view of the Sinnington floods in 1927, from the same postcard set as before. Here, an open-topped car negotiates the water at the bottom of Sinnington Cliffe. (Sydney Smith)

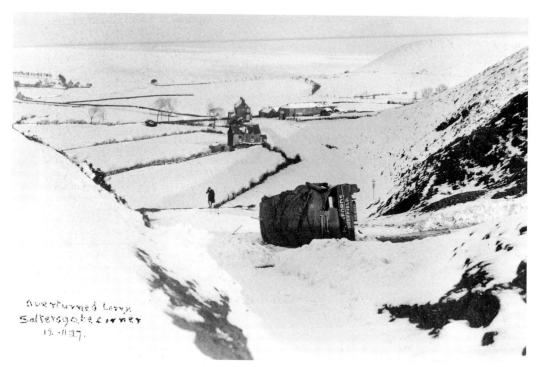

An overturned lorry at Saltersgate Corner, 12 November 1927. The Pickford's lorry from Sheffield overturned in icy conditions while negotiating Saltersgate Bank. (Sydney Smith)

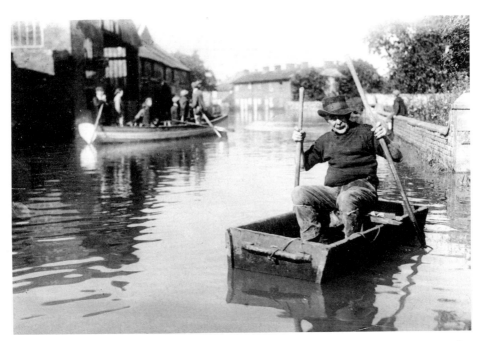

Floods at Brawby, September 1931. The makeshift boat is a scalding tub, used for removing the hair from slaughtered pigs' carcasses. (Sydney Smith)

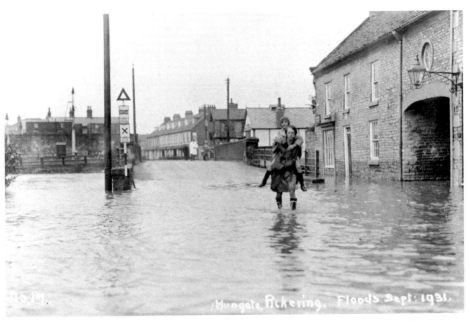

Freda Rogers walking through flood water near Hungate Bridge with Peggy Maud (aged eleven) on her back, September 1931. The railway signal box, the white fish and chip shop and the buildings on the right have all since been demolished. The railway line was level with the man walking in a white coat, but railway trucks can be seen elevated on the left, to enable coal to be tipped into the coal yard bays. The coal yard has now been demolished to make way for a new supermarket. (Sydney Smith)

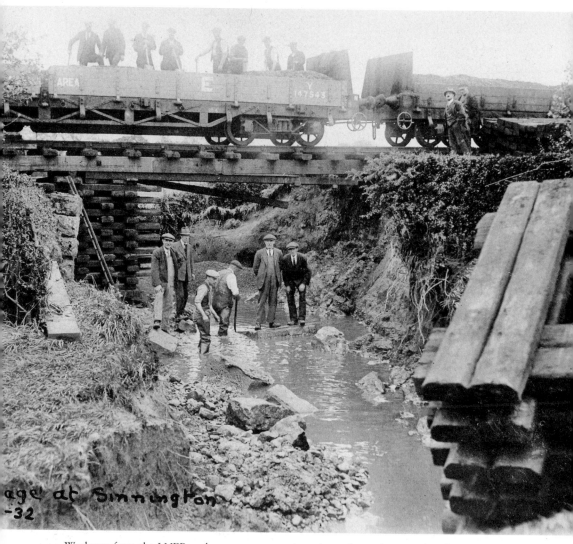

age at Sinnington
-32

Workmen from the LNER make emergency repairs using railway sleepers after flood damage at a bridge in Sinnington, 22 May 1932. (Sydney Smith)

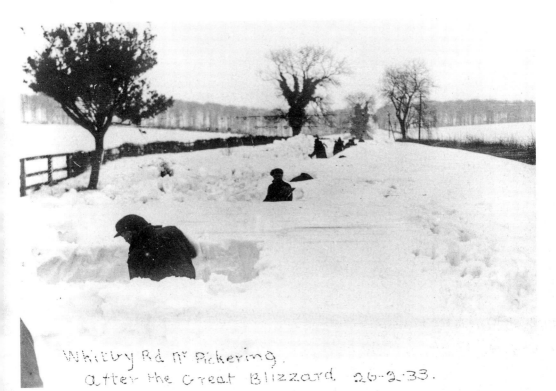

Whitby Rd nr Pickering.
after the Great Blizzard. 26-2-33.

The Whitby road near Pickering, after the Great Blizzard, 26 February 1933. Unemployed men were hired by the day to cut the snow from the main road, here at High Kingthorpe. (Sydney Smith)

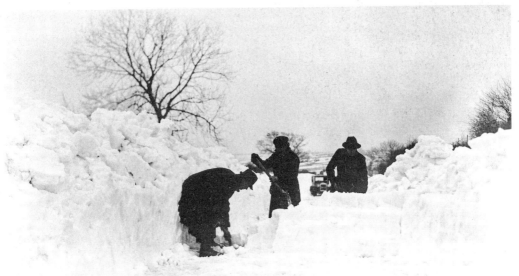

Whitby Rd nr Lockton. Pickering.
after the Great Blizzard. 26-2-33.

Snow cutting on the main road to Whitby near Lockton, after the Great Blizzard. (Sydney Smith)

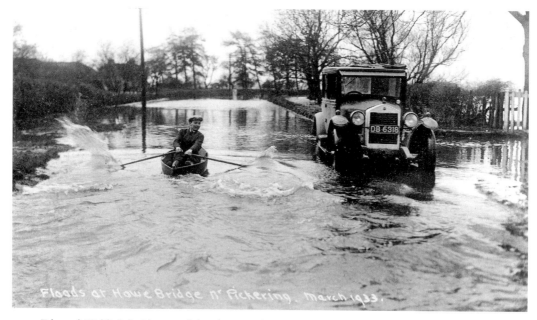

Edmund ('Eddie') Smith, son of the photographer, rows his boat down the main Pickering to Malton road at Howe Bridge in March 1933. The boat was made by Sydney Smith and carried on the car roof to flooded villages. The level of the highway has since been raised, and drains laid below, in order to prevent flooding. (Sydney Smith)

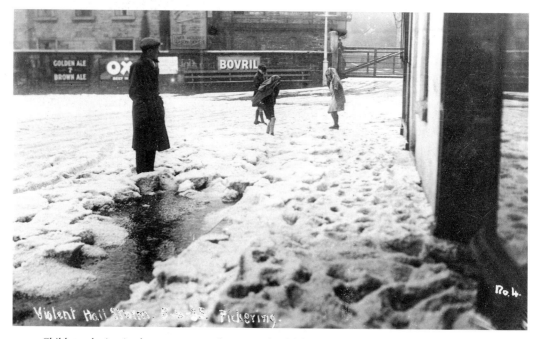

Children playing in short trousers and summer frock after a freak hailstorm left a covering of several inches of hailstones on 5 June 1935. This view is of the bottom of Pickering Market Place; others in this set of postcards show workmen from the council clearing the roads and footpaths. The sports day at Lady Lumley's Grammar School was cancelled. (Sydney Smith)

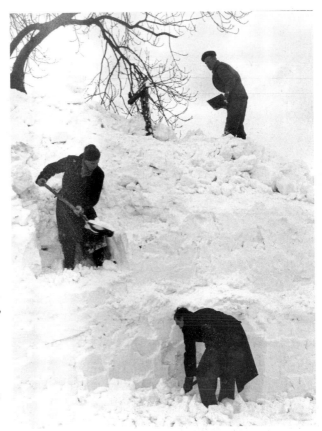

Alfred Manning (top right) and two other workmen from Rogers Nurseries in Pickering, after having been laid off work due to the bad weather, are cutting snow on the Whitby road near Lockton. Unemployed men were paid by the day to clear snowdrifts – each was given a length of road to clear. (Sydney Smith)

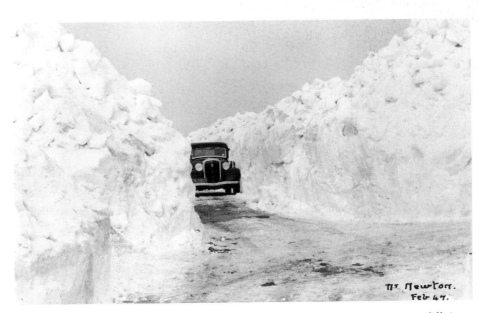

The Smiths' family car is parked in snowdrifts near Headlands Lane Newton-on-Rawcliffe in February 1947. (Sydney Smith)

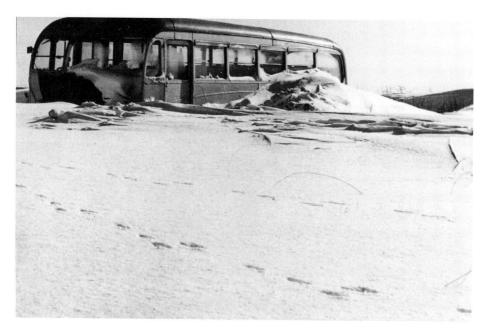

A coach abandoned in a snowdrift near the Fox and Rabbit Inn on the Whitby road in February 1947. It was taking thirty-two passengers back home to Whitby after a visit to the pantomime in Leeds. The bus was still embedded in the snowdrift a month later on 14 March. The passengers spent three nights sleeping in Lockton Village Hall, before returning home by train. (Sydney Smith)

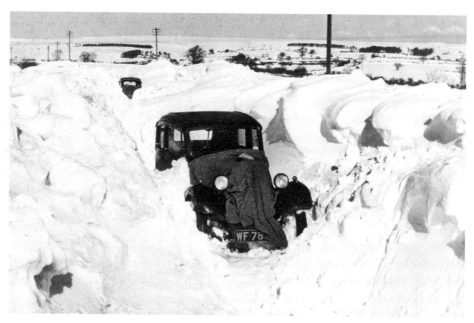

This car abandoned in a snowdrift near Lockton belonged to District Nurse Brown of Thornton-le-Dale, who had delivered a baby in a home confinement at a farm near the Fox and Rabbit Inn. An RAF mountain rescue team was called in, but the car was later recovered by Tommy Taylor of Pickering, using a Bismarck four-wheel drive armoured vehicle. The date is again February 1947. (Photographer unknown)